IMAGES
of America

PERTH AMBOY'S HISTORIC NEIGHBORHOODS

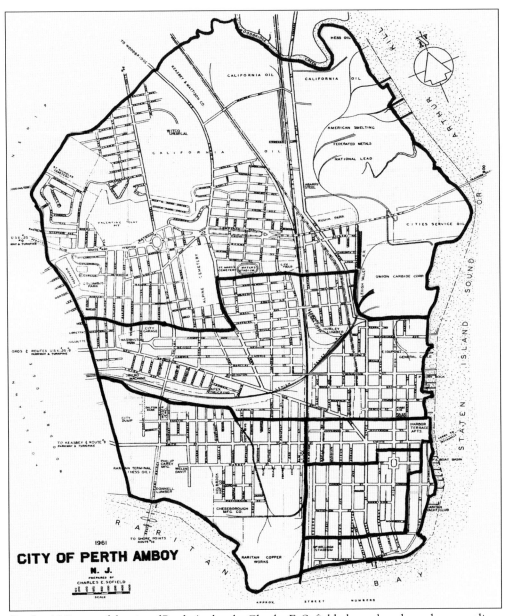

On this 1961 map of the city of Perth Amboy by Charles E. Sofield, the authors have drawn outlines of the historic neighborhoods as they have defined them. It shows the city at its industrial peak, identifying many industries, parks, and transportation routes within and out of the city. While these neighborhoods had some unique characteristics, they all had residential, recreational, and business facilities, enjoyed by all residents. (Courtesy of John Sofield.)

ON THE COVER: This 1946 view of the intersection of Smith and Hobart Streets, taken by Stephen M. Dudash, offers a glimpse of Perth Amboy at its retail zenith. With its mix of small shops, department stores, professional offices, and banks, the business district attracted visitors from Perth Amboy and the entire surrounding area. The authors fondly recall shopping in all of these stores, which offered something for everyone. (Courtesy of Marilyn Dudash Anastasio and Carl Dudash.)

IMAGES
of America
PERTH AMBOY'S
HISTORIC
NEIGHBORHOODS

Gregory Bender, Albert Jekelis,
Marilyn Dudash Anastasio, and Mona Shangold

ARCADIA
PUBLISHING

ISBN 978-1-4671-0839-3

Published by Arcadia Publishing
Charleston, South Carolina

Printed in the United States of America

Library of Congress Control Number: 2022932527

For all general information, please contact Arcadia Publishing:
Telephone 843-853-2070
Fax 843-853-0044
E-mail sales@arcadiapublishing.com
For customer service and orders:
Toll-Free 1-888-313-2665

Visit us on the Internet at www.arcadiapublishing.com

Dedicated to our families, classmates, and friends;
all past, present, and future Perth Amboy residents;
and especially Frances Jekelis Tripka and Stephen M. Dudash

CONTENTS

ACKNOWLEDGMENTS

We are grateful to many individuals and institutions for their assistance in preparing this book. We are especially indebted to the late Frances Jekelis Tripka and the late Stephen M. Dudash for their extraordinary collections of Perth Amboy images, which are currently owned by the authors. In addition, we have overwhelming gratitude to our ancestors for giving us the opportunity to live in Perth Amboy.

We are grateful to Faith Bender Vallone and Thomas S. Anastasio for their valuable technical assistance and to Kenneth Mirkin for his editorial assistance.

We especially thank Mary Ellen Pavlovsky, who provided several wonderful images and a wealth of information and inspiration. We are also grateful to many others who provided images and/or information: David Greenhouse and the late Muriel Brandwein Greenhouse, Charney Madrazo Herst, Bertha Faffer James, Marilyn Millet Goldberg, Amy Sussman Shearer, Herschel Chomsky and the Perth Amboy Free Public Library, the Jewish Historical Society of Central Jersey, Norma Stein Witkin, Eva Bloom Schlachter, Howard Kroop, Daniel Kaden, the Steuber Family, Paul Bender, Nadine Sedor Rebovich, Alan Tedesco, Carl Dudash, Stephanie Bartz, Vevy Sewitch, Burton Sher, Barbara Booz, John Sofield, Daniel Chazin, and "Perth Amboy Virtual Museum" Facebook page cofounder William Szemcsak. We also thank Facebook groups "Perth Amboy the Way We Remember It" and "Perth Amboy My Home Town" for their help and support.

Unless otherwise noted, all images appear courtesy of the authors. Some images in this volume appear courtesy of the Perth Amboy Free Public Library (PAFPL), the Jewish Historical Society of Central Jersey (JHSCJ), Paul Bender (PB), and Mary Ellen Pavlovsky (MEP). Some images were produced by Gaspar Brothers (GB), Isadore Rubenstein (IR), and Louis P. Booz III (LB).

INTRODUCTION

Perth Amboy has a very rich history, dating back to pre-colonial days. It was inhabited by the Lenape Native Americans when the first settlers arrived from Scotland in 1685. Like all those who arrived later, they recognized that the city's location provided great potential for living, thriving, and growing. Centrally located in New Jersey on Raritan Bay, where the Arthur Kill meets the Raritan River, the city includes a deepwater seaport, a marina, white sand beaches, many historical landmarks, and proximity to New York City.

Industrialization and immigration changed the land and lifestyle of its residents. As immigrants moved into areas with those of similar ancestry and culture, their descendants worked and played with people from other cultural backgrounds. The resulting assimilation created a strong, unified community in which Perth Amboy residents accepted, respected, and celebrated their differences in racial, religious, and ethnic harmony.

Perth Amboy has always been a city of immigrants. While immigration patterns changed over time, significant numbers emigrated from most European countries, as well as South America, Central America, Caribbean islands, and Asia. They were all proud of their accomplishments and had a strong work ethic. What distinguished Perth Amboy's immigrant population was that, upon arrival in Perth Amboy, most people were committed to helping each other and to making Perth Amboy better. All contributed to the culture and spirit of Perth Amboy.

Perth Amboy began as a port and goods distribution center. It thrived during the rise of the Industrial Age, suffered during the decline of the Industrial Age, and has evolved again as a port and goods distribution center. Perth Amboy had been a bucolic town in the 19th century, hosting a utopian community, the Raritan Bay Union, and a prestigious military academy, Eagleswood. Later in the 19th century, much of the rural tranquility was disrupted by the emergence of the industrial age and the coming of the railroads. The growth of industry demanded labor, and Perth Amboy's population grew rapidly.

Many immigrants of the 20th century were from Eastern Europe. They were quite a diverse group and spoke many different languages. They faced and met many challenges, including World War I, a pandemic, an economic depression, and World War II. In many ways, World War II, with its shared pain, became the ultimate unifier. The authors, children of the World War II generation and grandchildren of the immigration boom, were the beneficiaries of this amalgamation. Always admiring and applauding talent and achievement, our generation was largely oblivious to racial, religious, and ethnic differences. Instead, we chose to emphasize, promote, and celebrate the common goals, values, and experiences we shared.

All parts of the city had multiple languages, cultures, and customs. The schools brought all differences together. As children learned the American language and customs, they shared their new knowledge with their families. This was, and still is, especially true in homes where English was not the parents' language. Students graduating from public elementary schools throughout the city met for middle school at the Shull School or Grammar School and then for high school at Perth Amboy High School. Parochial school students did the same, attending either St. Mary's

High School or Perth Amboy High School. Children became teammates and good friends at school, and adults from different backgrounds also came together to work and socialize. The many different houses of worship enabled their members to maintain and practice their beliefs, always respecting other faiths and emphasizing the common goals and grounds they shared.

The many railroad lines had tracks distributed throughout the city, making it impossible to use the expression, "You live on the wrong side of the tracks." Although the names of the railroad lines have changed and some of the tracks have disappeared, the railroads were an important part of the city's history.

The residences, businesses, and industries intertwined in each neighborhood gave the areas their own identities. This book is intended to highlight some unique, historic neighborhoods in Perth Amboy and what makes or made them special to the generations that lived and worked there. We have divided this book into six large geographic areas, some of which include several smaller "named" historic neighborhoods.

The large "Northern" section includes the Maurer, Budapest, Alpine, and outer State Street neighborhoods, all of which have unique characteristics. The industrial Maurer neighborhood at the extreme northeastern corner of the town was originally settled by Henry Maurer, a German-American who established a brick manufacturing company and built a home, village, and school in this area. The Budapest neighborhood had a large population of Hungarian descent intermixed with Poles, Slovaks, Russians, and other Eastern Europeans. The Alpine neighborhood surrounds the Alpine Cemetery, while the outer State Street neighborhood is primarily industrial.

Our large "Central" section includes the hospital, inner State Street, and Hall Avenue neighborhoods. Each of these smaller neighborhoods included residences, schools, businesses, houses of worship, and their own ethnic enclaves.

The "Dublin" section was originally home to a large Irish population, one of the first groups of immigrants to live in the area. As in most areas of town, other ethnic groups moved into the Dublin section.

The "Smith Street" section was the city's business and retail center, but it also included residences, schools, houses of worship, and activity centers.

The "Waterfront" section included residences, activity centers, athletic facilities, and businesses and industries that involved the waterfront. All ethnic and religious groups shared the waterfront's beach area, and users included fishermen with boats, bathers on the beach, and walkers on the boardwalk. International Park, recently added on Sadowski Parkway, recognizes the importance of the city's immigrants.

The "Historic" section is primarily residential, but it includes city administrative offices, an elementary school, businesses, and major historical landmarks. Perth Amboy was the capital of the Province of East Jersey; City Hall is the oldest city hall in continuous use in the United States.

Perth Amboy was a wonderful place in which to live and grow up. Perth Amboy, its people, and their neighborhoods all continue to evolve and reinvent themselves, even as reminders of the city's rich past remain. We have structured this book by historic neighborhoods, presenting some key images in these neighborhoods and providing dates and locations for most images. Wherever possible, we have provided specific facts about the people and their businesses. We encourage readers to explore interactively today's Perth Amboy, starting with images of interest, by using the satellite view on digital map applications, such as Google Maps. This will allow readers to conduct their own real or virtual walking tours of Perth Amboy's historic neighborhoods and see them as they are today. Readers will also be able to see current construction and the next iteration as it is coming. Those who are close enough to visit Perth Amboy in person can use this book as a guide for a walking, driving, or bicycling tour of the city. A lot of glorious history remains, and more is still to come. Our ancestors came to Perth Amboy searching for the American Dream, and they found it.

One

FIRST GOVERNMENT
HISTORIC NEIGHBORHOOD

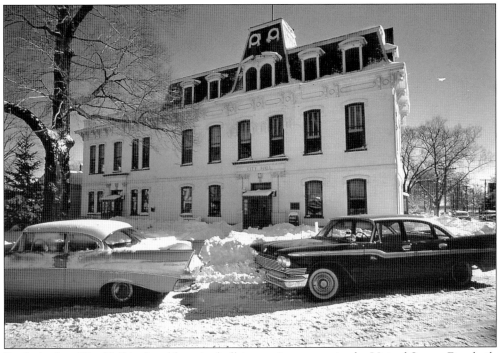

Perth Amboy City Hall is the oldest city hall in continuous use in the United States. First built in 1714 as a courthouse, the building was destroyed by fire twice (in 1731 and 1764) and rebuilt each time (in 1745 and 1767). The New Jersey General Assembly met to ratify the Bill of Rights at this location in 1789, making New Jersey the first state to do so.

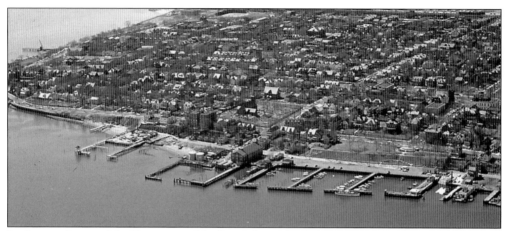

In this aerial view of the Historic neighborhood, facing to the southwest, several landmarks can be seen. City Hall is on the right; St. Peter's Church is in the center of the photograph; the Proprietary House is in the upper central part; and MacWilliam Stadium is at the top. The neighborhood also includes several professional and industrial businesses and many private residences.

HISTORIC NEIGHBORHOOD

Perth Amboy's Historic neighborhood is adjacent to the Waterfront in the southeastern part of the city. It extends from Lewis Street on the south to Market Street and slightly north of Market Street on the north and from Water and Rector Streets on the east to the tracks of the Pennsylvania Railroad and Central Railroad of New Jersey on the west.

The statue of George Washington in Market Square—now City Hall Park—was dedicated in September 1895. It is located across from City Hall at the north end of the park, where it faces northward on High Street. The statue was a gift from Perth Amboy's Scandinavian community in appreciation of the community's love for the United States, their adopted country.

An excellent example of Perth Amboy's capabilities, the terra-cotta statue of George Washington was designed by Danish sculptor Nels Nielsen Alling, working at the New Jersey Terra Cotta Company. Alling remained in Perth Amboy, where he established a monument business. The statue was recently restored by the city. On the right side of this image is the historic Thomas Bartow House.

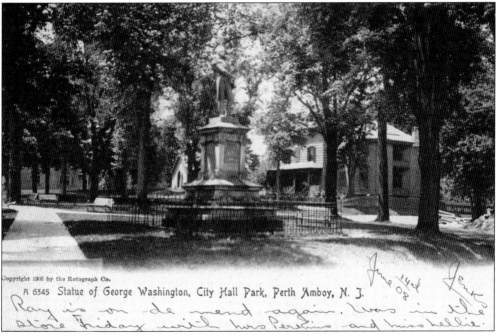

GEO. WASHINGTON STATUE, CITY HALL PARK

PERTH AMBOY, N.J.

Copyright 1905 by the Rotograph Co.
A 6345 Statue of George Washington, City Hall Park, Perth Amboy, N. J.

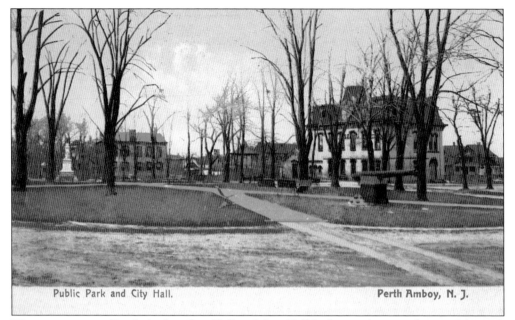

Public Park and City Hall. Perth Amboy, N. J.

This winter view of Perth Amboy City Hall and City Hall Park provides a good view of the park and the buildings. The cannon was placed in the park in 1903, and City Hall was renovated in 1908. City Hall Park was the site of the old colonial market, which was originally called "Market Square" because of its shape as an island in the center of the intersection.

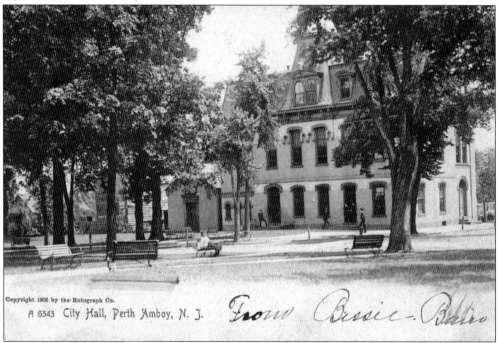

A 6343 City Hall, Perth Amboy, N. J.

This view, prior to the 1908 renovation and expansion of City Hall, shows the surveyor general's office and city stables and barn on the left side of the building. The left entrance to the building led to the police headquarters and city jail. The surveyor general's office, built in 1852, contained the city maps and property ownership records and served as a meeting place for the East Jersey Proprietors.

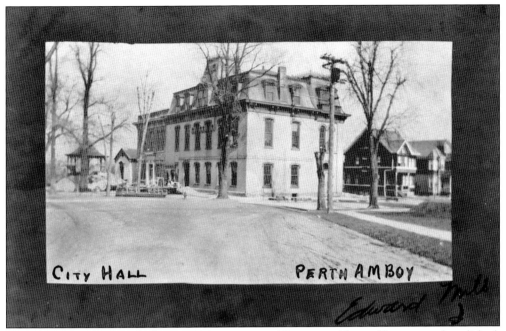

This view shows City Hall after its 1908 renovation. The city stables and barn were demolished, and the surveyor general's office was moved 40 feet to the north, where it is now a museum of Perth Amboy's early history. When the renovated City Hall opened July 4, 1908, it included a new police headquarters and an expanded city jail in the north side addition.

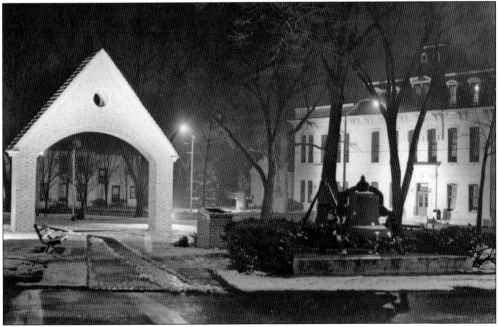

The Bill of Rights Arch, in the center of City Hall Park, was erected and dedicated November 20, 1987, as a tribute to New Jersey as the first state to ratify the Bill of Rights and to Perth Amboy as the first capital of East Jersey. The Bill of Rights was first signed in the old courthouse, the present city hall, on November 20, 1789.

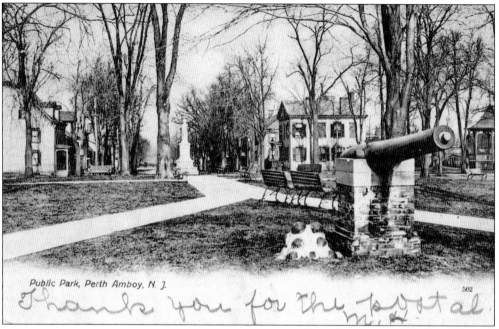

Public Park, Perth Amboy, N. J.

Thank you for the postal 502

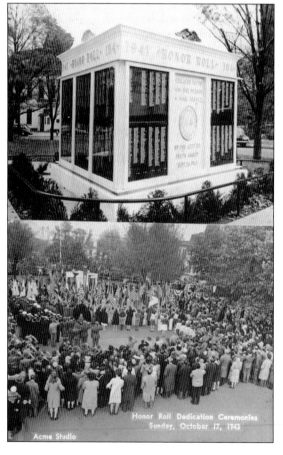

Honor Roll Dedication Ceremonies
Sunday, October 17, 1943

Acme Studio

Perth Amboy's memorials included several artillery pieces. This impressive civil war cannon, located at the south end of City Hall Park, was a gift from the James Gandy Post Grand Army of the Republic. The cannon was mounted on a brick base, with a stack of cannonballs encased in concrete alongside the base. The cannon was removed sometime in the 1940s.

The city's monument to Perth Amboy's World War II veterans, containing all of their names, was located at the south end of City Hall Park until it was damaged by an automobile accident. The city relocated all of the panels to the walls of the city council chamber in City Hall. In 2005, the city erected the Perth Amboy Veterans' War Memorial/ Wall of Honor at Sadowski Parkway.

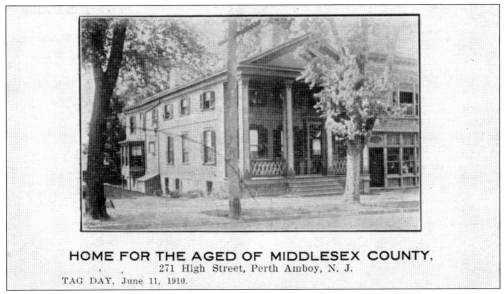

HOME FOR THE AGED OF MIDDLESEX COUNTY,
271 High Street, Perth Amboy, N. J.
TAG DAY, June 11, 1910.

The Home for the Aged of Middlesex County stood on High Street at the edge of Market Square. It was often described as one of the community's most worthy charities and was well-known for its open and welcoming policies. The facility was always open to all, without regard to race, creed, or religion.

Market Street, Perth Amboy, N. J. 213344

Market Street received its name in 1684 because the public market (Market Square) had been established at the intersection of Market and High Streets. The street extends across the Historic neighborhood from Water Street on the east to Second Street on the west, where it passes over the Pennsylvania Railroad and Central Railroad of New Jersey tracks. Market Street continues west of the railroad tracks, extending across the Dublin neighborhood.

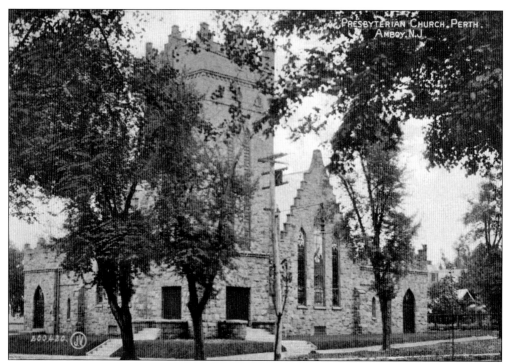

Perth Amboy's Presbyterian community dates back to 1731, when a church facility was requested and constructed on State Street, between Smith and Market Streets. That building was replaced by a new church, which opened in 1803 on the southeastern corner of Market and High Streets. The First Presbyterian Church of Perth Amboy built its current facility at the same location in 1902, where it can be seen across the street from City Hall Park. As shown in the photographs above and below, it is English Gothic in style and has a large tower on one corner and two smaller towers flanking the building.

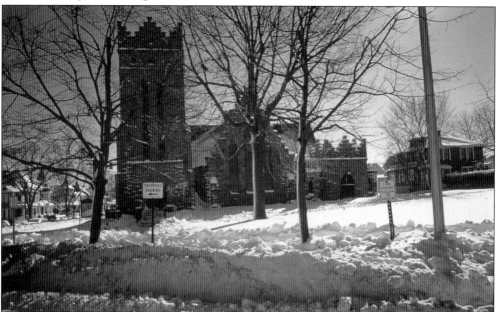

The First Presbyterian Church had a very active congregational community that attended weekly services, Sunday school, and many seasonal activities. The Strawberry Festival was held every spring; Halloween parties were held every October; and a colonial fair was held during each winter. In response to the needs of the congregation, the church added Spanish services. Classrooms in the auditorium held a daycare center.

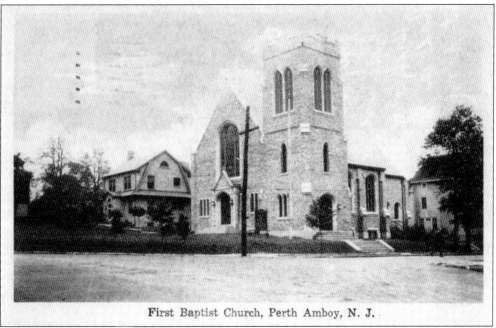

First Baptist Church, Perth Amboy, N. J.

The First Baptist Church occupies the high ground on the southwest corner of Market Square. This building replaced the old structure located on High Street. The cornerstone was laid on June 24, 1923, in a ceremony celebrated by both civic and religious leaders of Perth Amboy. The First Baptist community has deep roots in Perth Amboy; records document that it was organized in August 1818.

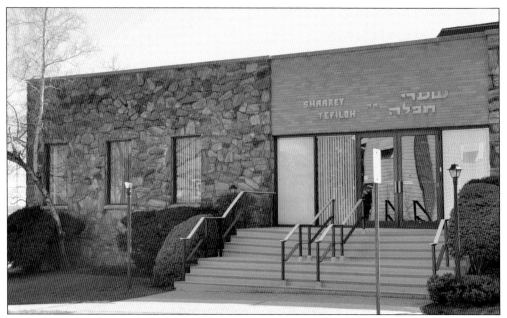

When Shaarey Tefiloh synagogue on Madison Avenue was destroyed by fire in 1975, a new building was quickly constructed on the corner of Market and Water Streets in 1976. Because of declining membership, Shaarey Tefiloh closed its doors and sold this building in 2014 to Science of Spirituality, an international organization, open to all and committed to a spiritual way of life based on meditation and service to others.

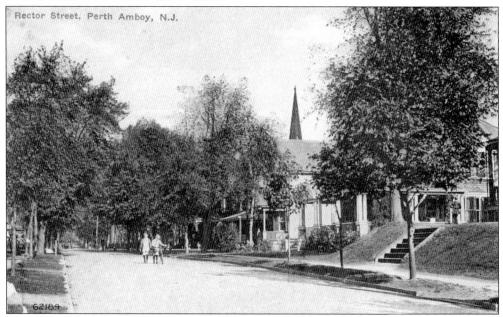

Named in honor of the Rectors of St. Peter's Episcopal Church, Rector Street extends through the entire Historic neighborhood from Lewis Street on the south to Market Street on the north. It continues farther north beyond this neighborhood to Washington Street. The southern part of this street is home to St. Peter's Church and its graveyard at the corner of Gordon Street. Most of Rector Street remains primarily residential.

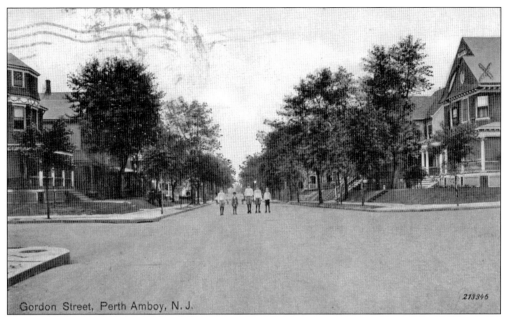

Gordon Street, Perth Amboy, N. J.

Gordon Street was named in honor of Thomas Gordon, an early settler who died in 1722 and was buried in St. Peter's Churchyard. Always a residential street with a few small shops, Gordon Street extends from Front Street on the east to Second Street on the west, where it was cut off when the railroad tracks were relocated below grade. A short section remains in the Dublin neighborhood.

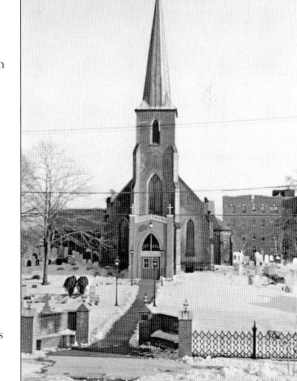

St. Peter's Church, the oldest Episcopal parish in New Jersey, held its first service in 1685, and the present churchyard site predates the American Revolution. The current church building replaced the original building in the 1850s and has undergone many renovations since then. It was added to the National Register of Historic Places in 1977.

Thomas Mundy Peterson, a school janitor and handyman, became the first African American to vote in the United States following the passage of the 15th Constitutional Amendment. Voting on March 31, 1870, in a special election concerning the city charter, Peterson voted to maintain it. Peterson is buried in the cemetery of St. Peter's Church.

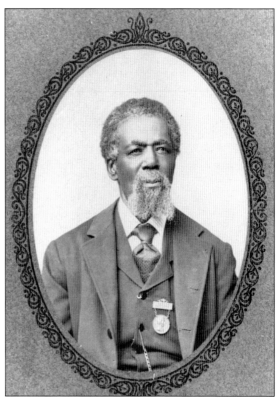

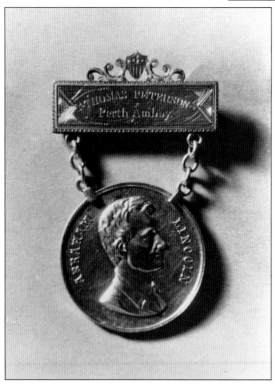

The Peterson Medal was presented to Thomas Mundy Peterson on Memorial Day in 1884, to commemorate his very significant vote earlier that year. The citizens of Perth Amboy raised the funds for this solid gold medallion, depicting Abraham Lincoln, and had it cast locally. This medallion now resides at Xavier University.

Originally an Orthodox Jewish synagogue that was named in memory of Max ("Mordecai," in Hebrew) Wolff, Beth Mordecai became Conservative in 1921. The building shown here, located on High Street between Market and Gordon Streets, was built in 1926. Beth Mordecai continued to serve the Conservative Jewish population at this location, which was the center of both spiritual and social activities for its membership.

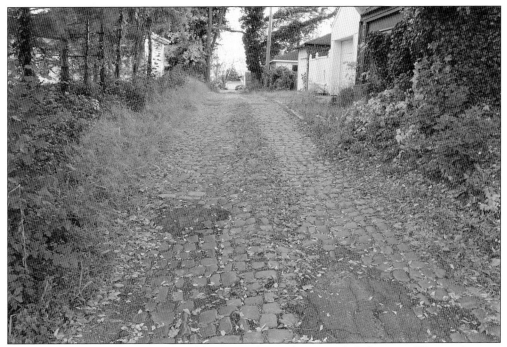

One "secret" of Perth Amboy is this old, unnamed street between High Street and Kearny Avenue. One section extends south from Gordon Street toward Harrison Place, then turns, and emerges on Kearny Avenue. Another section extends north from Gordon Street toward Market Street. Many parts of the original Belgian block pavement (brought to Perth Amboy as ship's ballast) are still visible, adding to the historical nature of this path.

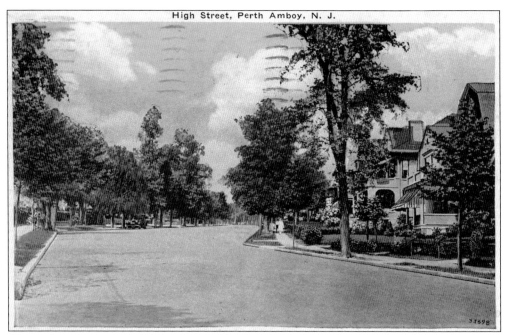

The widest street in the Historic neighborhood, High Street extends through the entire neighborhood from Sadowski Parkway on the south to Market Street on the north. It continues northward until its new extension takes it to State Street in the Northern neighborhood. This view faces northward from a point slightly north of Lewis Street, with distinguished residences lining both sides of the street.

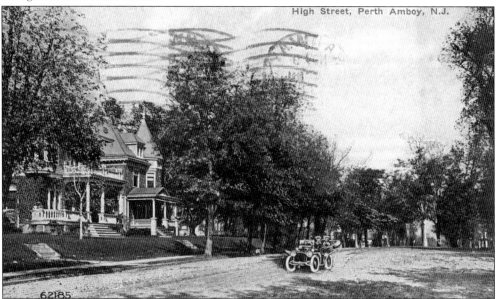

High Street, Perth Amboy, N.J.

There is much to see on High Street looking northward, toward nearby Market Street. Throughout the Historic neighborhood, High Street is almost entirely residential, marked by beautiful homes and trees along the wide street. At Market Street the view changes, with City Hall, Temple Beth Mordecai, the First Presbyterian Church, and the First Baptist Church all clustered together. Market Square is now City Hall Park.

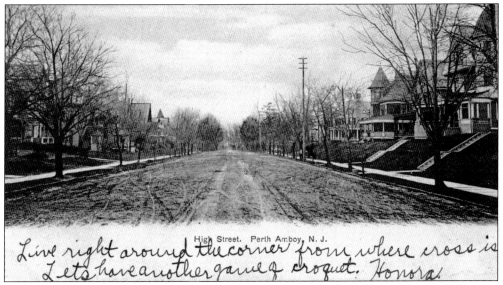

High Street. Perth Amboy, N. J.

Live right around the corner from where cross is. Lets have another game of croquet. Honora.

Many of High Street's characteristics were apparent even before the street was paved. In this winter scene, prior to street paving, the wide, empty street can be seen, lined by bare trees and old residential homes that were built long ago. The markings and tracks in the unpaved street reflect a considerable amount of traffic even then.

Built in 1904 at the corner of Madison Avenue and Patterson Street, No. 7 School was the public elementary school attended by all children residing south of Gordon Street for grades kindergarten through fifth grade. The school was within walking distance for all attendees, who got to know their classmates well, both in the classroom and in after-school activities.

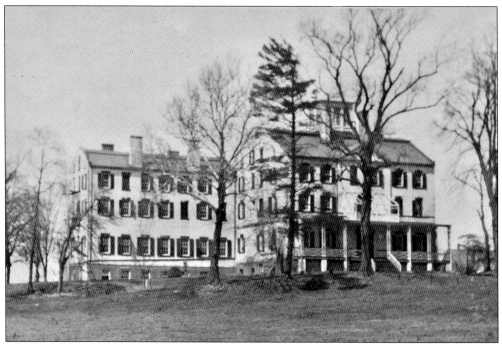

Built in 1762–1764, Proprietary House was the residence of colonial New Jersey's last royal governor and has had an exceptionally full history since then. (See more details on page 159.) The former governor's mansion was greatly enlarged and renamed "Brighton House" when it opened in 1809 as an elegant seaside resort hotel. East Coast socialites flocked to Brighton House until the War of 1812 disrupted business and bankrupted the hotel. When Brighton House and its surrounding 11.5 acres became the home of wealthy merchant Matthias Bruen in 1817, it was reputed to be America's largest private residence. Following Bruen's death in 1846, Brighton House again operated as an elegant hotel. The 1900 photograph above precedes the 1904 construction of Kearny Avenue, which is visible a few years later in the image below. (Above, courtesy of Mary Ellen Pavlovsky.)

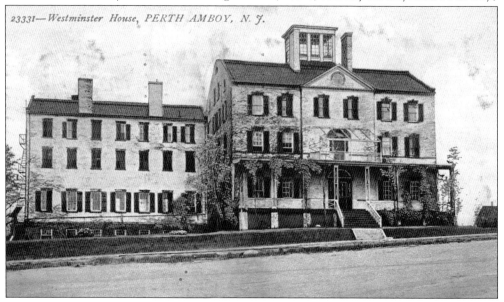

23331—*Westminster House*, PERTH AMBOY, N. J.

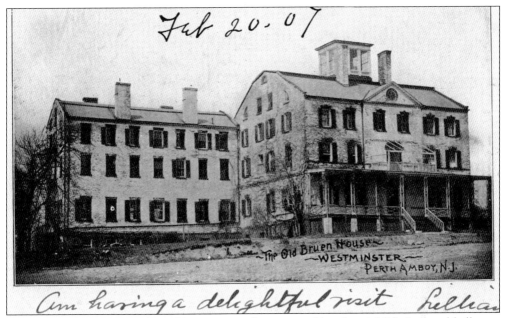

Until the early 1880s, Brighton House was at the center of local social life. Its hotel ballroom and broad lawn were greatly enjoyed by the community. The mansion acquired the name "Westminster" when, from 1883 until 1903, it served as a home for retired Presbyterian ministers and their families. In 1903, immigrant J.P. Holm bought the Westminster, hoping to preserve the building as a historic site.

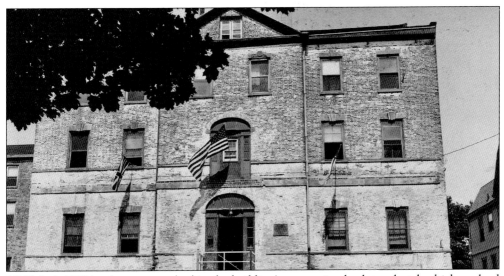

J.P. Holm's 1910 bankruptcy resulted in the building's conversion back to a hotel, which evolved into a boardinghouse by 1967, when Westminster Hotel was purchased by the State of New Jersey. With restoration still underway, Proprietary House was first open to the public during America's Bicentennial Celebration in 1976, as shown in this image. (Photograph by Louis P. Booz III, courtesy of Mary Ellen Pavlovsky.)

David Kaden, with his back to the camera, is walking next to his company's truck (D. Kaden Trucking Company) as he awaits the start of a city event featuring local business equipment. This truck is in line for the "truck parade" on Sadowski Parkway. The D. Kaden Trucking Company was located on Second Street between Patterson Street and Gordon Street. (Courtesy of Daniel Kaden.)

This welded "mufflerman" graces the entrance to a scrap operation on Second Street, in front of the New Jersey transit line. The tradition of scrap businesses on Second Street remains long after the cleanup of the large Goldberg scrapyard at the southern end of the street, which is now being developed as a park. The New Jersey Department of Motor Vehicles previously conducted new driver road tests here.

Two

SEAPORTS AND PARKS
WATERFRONT NEIGHBORHOOD

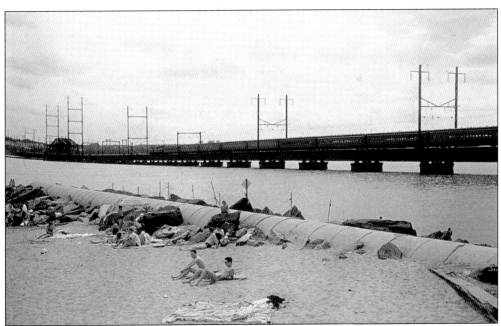

Bathers enjoyed the sun on the Second Street beach, near the discharge pipe from the adjacent sewage plant. The south-facing beach welcomed sunbathers and also included a small boat-launching ramp. In the background, a Pennsylvania Railroad commuter train, with its GG-1 electric locomotive, is heading to change engines in South Amboy, where the electrification ended. The 1908 swing bridge was damaged during Hurricane Sandy, and a replacement is under construction.

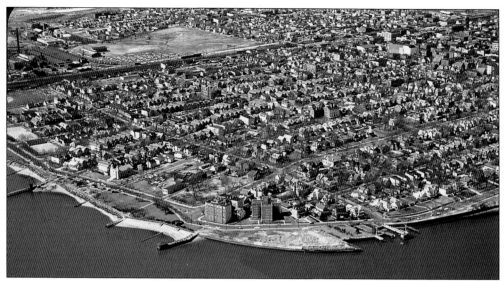

The center of the Perth Amboy Waterfront neighborhood is the "Point" of the city, the curving section of Water Street between High and Lewis Streets. It has been characterized as the beginning of Raritan Bay, with the Raritan River flowing from the left and the Arthur Kill from the right. The extended seawall and landfill are visible, as are St. Demetrios Church, the Tennis Club building, and Caledonia Park.

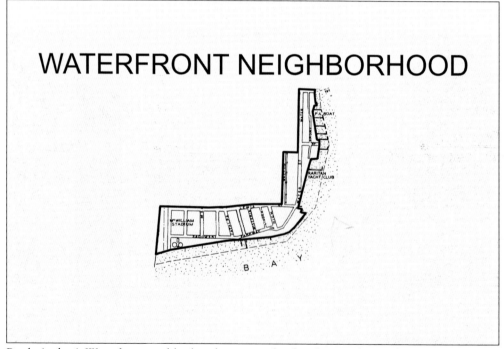

Perth Amboy's Waterfront neighborhood occupies the shoreline in the southeastern part of the city, extending southward from the ferry and continuing westward to the tracks of the Pennsylvania Railroad and Central Railroad of New Jersey. The neighborhood extends inland about one or two blocks to Water and Rector Streets and to Lewis Street. Landmarks include the ferry, the Raritan Yacht Club, and MacWilliam Stadium.

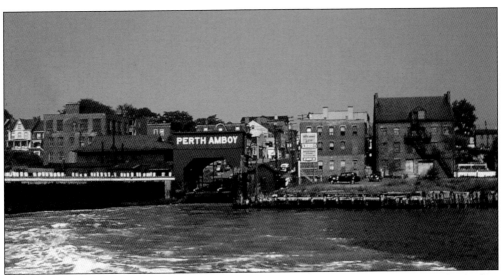

Several landmarks are seen in this welcoming view of Perth Amboy from a ferry on the Arthur Kill. The ferry slip complex and adjacent terminal building were built in 1904, and the terminal building included a waiting room and ticket booth. The Ferry Hotel, on the northwest corner of Front and Smith Streets, bears a sign advertising Schindels. The tea warehouse was next to the hotel on Front Street.

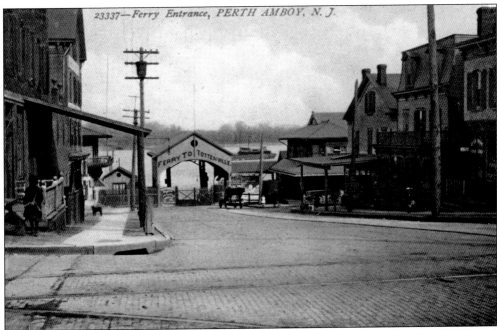

Until 1948, the Perth Amboy ferry slip and waiting room were operated by the Staten Island Rapid Transit, whose trains in Tottenville connected to New York City ferries at St. George, providing a low-cost route to lower Manhattan. In Perth Amboy, the ferry connected to streetcar lines and buses. The tracks of the Smith Street line are in the foreground.

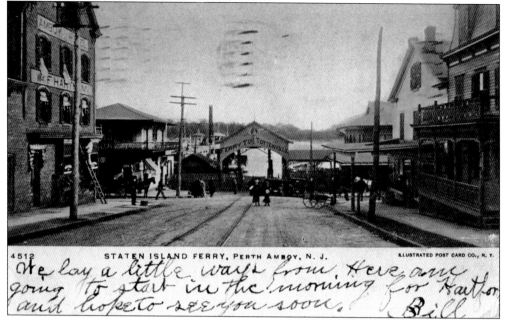

4512 STATEN ISLAND FERRY, PERTH AMBOY, N. J. ILLUSTRATED POST CARD CO., N. Y.

We lay a little ways from here and going to start in the morning for Harbor and hope to see you soon. Bill

This postcard provides a representation of the eastern end of Smith Street, facing eastward. The trolley tracks at the intersection of Water and Smith Streets constituted the terminal end of the Smith Street trolley line. Historic streetcar maps suggest that there were switching tracks on Water Street that provided a way to turn the trolleys at the end of the line.

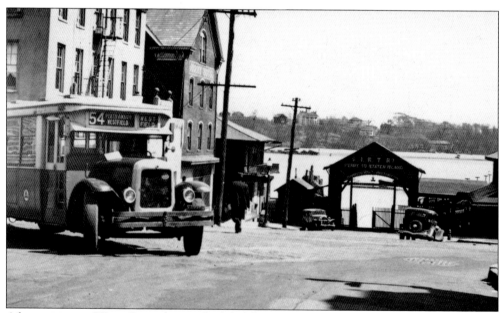

After waiting on Water Street for its scheduled departure, Public Service Bus No. 54 turns right onto Smith Street to begin its route to Westfield. The bus would continue on Smith Street, Oak Street, New Brunswick Avenue, and then north on Convery Boulevard on its route to Westfield. Many bus routes began and ended at the ferry slip.

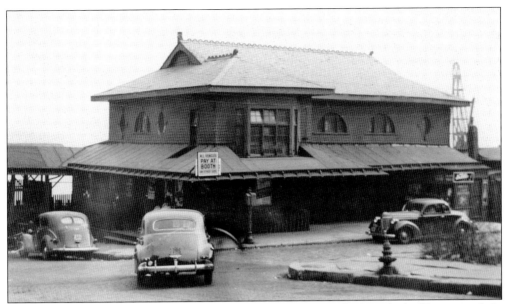

By the 1940s, the large waiting room and ticket office adjacent to the ferry slip had become a dark, foreboding structure, although it had previously been painted in brighter colors. The Outerbridge Crossing had opened June 29, 1928, providing unlimited automobile crossings, while each ferry boat carried only nine cars and a few passengers. Cars lined up on Front Street while waiting to board the arriving ferry.

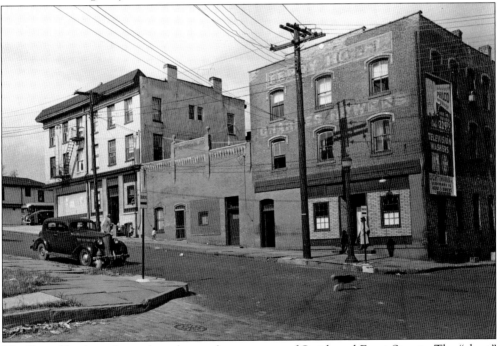

The Ferry Hotel was located on the northwest corner of Smith and Front Streets. The "ghost" signage echoes its more glorious past as a safe place for passengers to stay after missing the last evening ferry back to Staten Island. The hotel and adjacent buildings were soon to be demolished for the construction of the Harbor Terrace Apartment complex and parking lots. (LB.)

Adjacent to the Ferry Hotel at Front and Smith Streets was a second-hand store at Water and Smith Streets, with a restaurant between them, according to the 1914 Sanborn Fire maps. Immediately behind the hotel was a cigar warehouse, which must have provided the guests with an aromatic welcome to Perth Amboy. The buildings were residences at the time of this photograph. (LB.)

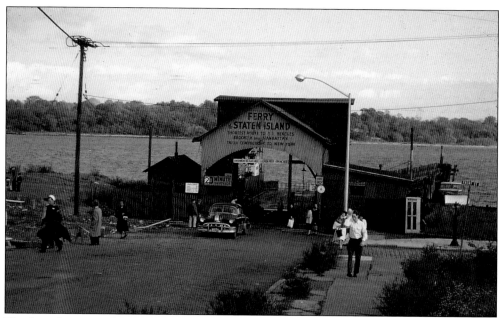

The ferry slip appears less attractive in this 1956 photograph, after a fire had destroyed the adjacent waiting room and ticket booth. The small Sunrise ferry had arrived from Staten Island, and cars and passengers were departing. The buildings along Smith Street had been razed in preparation for redevelopment of the area. Still surviving in front of the slip is the ubiquitous phone booth.

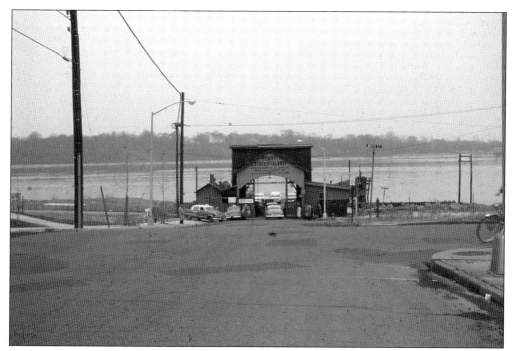

Looking even more run down in this 1960 photograph, the ferry slip stands virtually alone at the eastern end of Smith Street. All surrounding land and fences have been cleared for redevelopment, and new streetlights are seen, providing security in this desolate area. Several passengers wait against the building, and cars are loading onto the small ferry, as space permits.

Members of the Perth Amboy High School class of 1964 and teacher Joseph Kerr took their last ride on the Staten Island Ferry in October 1963, before its official closing on October 16, 1963. Announcement of the impending cancellation of service had prompted the students to initiate a campaign to save the venerable service, but new highways and the Outerbridge Crossing provided inexpensive vehicle transportation and rendered the ferry noncompetitive.

In the late 1960s, the abandoned ferry slip was showing signs of decay. The small waiting room is now the Perth Amboy Ferry Slip Museum, with a collection of harbor artifacts and photographs. Condominiums have appeared along Water and Smith Streets, as the neighborhood has become more residential. The area north of Smith Street was a parking lot for a Navy facility and later for a harbor cruise line.

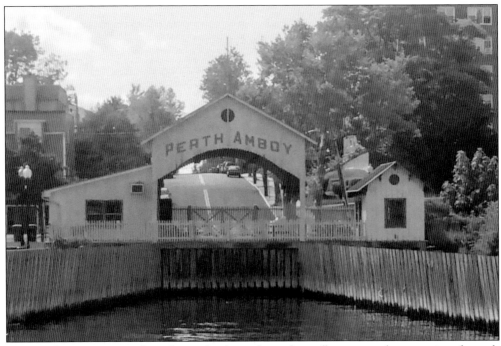

As seen from an approaching boat, the ferry slip today reflects partial restoration through community efforts, which are still ongoing. The Ferry Slip Museum, to the left, connects to the ferry slip's main concourse. "The Ferry Slip" concourse is available for concerts and is rated as one of the best summer music performance spaces in Middlesex County.

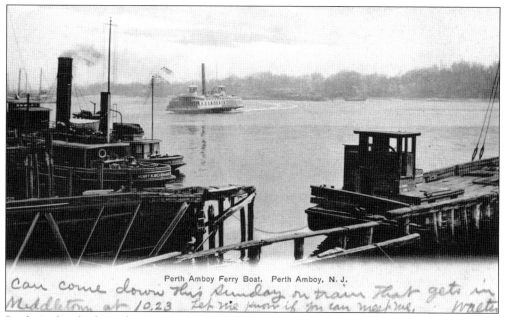

Perth Amboy Ferry Boat. Perth Amboy, N. J.

Can come down this Sunday on train that gets in Middletown at 10.23 Let me know if you can meet me. Walter

Perth Amboy had two ferries, which served different routes. The Long Ferry began in 1684 and served South Amboy from High Street, and the Staten Island Ferry began in 1709 and served Tottenville from Smith Street. Later, the Staten Island Ferry became part of the Staten Island Rapid Transit Company, which provided a train connection to St. George, where another ferry connected to Manhattan.

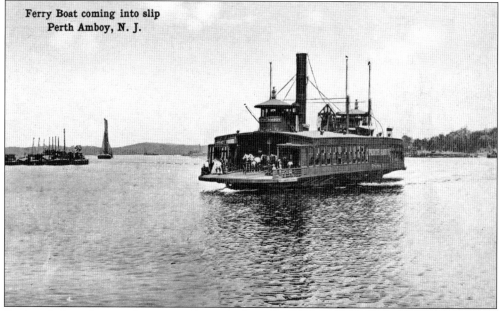

Ferry Boat coming into slip
Perth Amboy, N. J.

During their peak years, large steamboats, such as the *Perth Amboy*, seen here approaching the slip, provided all types of essential transportation. The boats carried passengers, livestock, and freight, since they provided the most cost-effective route to Staten Island. The Staten Island shoreline is on the right, while several tugboats are farther up the Arthur Kill on the left, at the Perth Amboy Dry Dock Company.

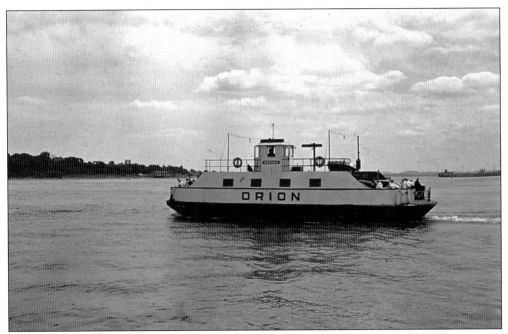

Perth Amboy's large steamship ferries were operated by the Staten Island Rapid Transit until 1948. From 1948 until 1963, small open-deck boats were operated by the Sunrise Ferry Company, which named most of them after stars and constellations. The *Orion*, pictured here, had a capacity for nine vehicles and had protected cabins for passengers, providing transportation between Perth Amboy and Tottenville.

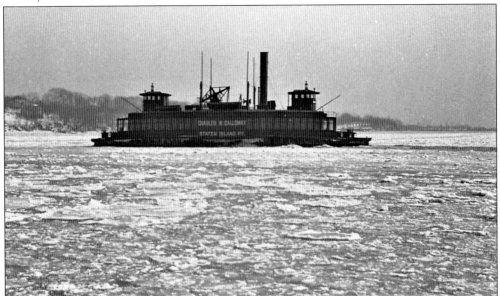

On a bitterly cold winter day in 1947, the Staten Island Railroad ferry *Charles W. Galloway* plows its way through the ice-packed Arthur Kill on its way to Perth Amboy. At a time when ice in "the Kill" was not unusual, the boat operators prided themselves on maintaining service. The large steamship ferries provided plenty of heat for the passenger seating areas. The ferry's final run was in 1948.

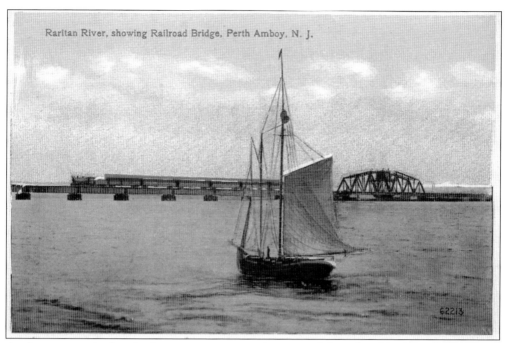

Raritan River, showing Railroad Bridge, Perth Amboy, N. J.

A schooner, a typical craft of oystermen, is seen sailing toward the railroad bridge, which replaced the original in 1908. When the original railroad bridge was constructed across the Raritan River in 1875, it was the first bridge east of New Brunswick to cross the Raritan River and was also the largest bridge of its kind anywhere in the world.

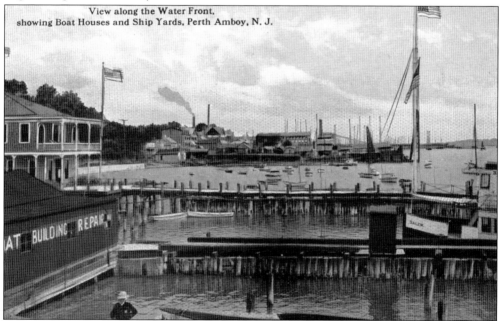

View along the Water Front, showing Boat Houses and Ship Yards, Perth Amboy, N. J.

This is an illustration of the eastern shore of the harbor area, looking northward from the docks of the Raritan Yacht Club. At the time, the area was mostly industrial in nature, featuring shipbuilding, mercantile facilities, and warehouses. The building that can be seen to the north, extending into the water, is the Naval Armory.

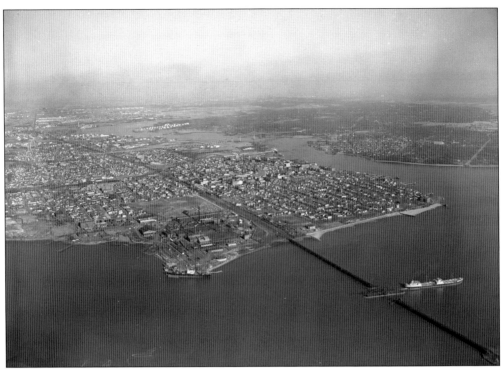

The narrow ship channels of the Perth Amboy train bridge required expert navigation, but this did not prevent ocean-going vessels from servicing the city's Raritan River industries. The ship passing through the bridge is an oil tanker, probably departing from the Hess Oil Company wharf upriver. At the Raritan Copper Works dock, a C-2 freighter is unloading ore or scrap metal for the refinery.

The southeastward view from the intersection of Front and Smith Streets shows that the warehouses previously lining Smith Street have been removed for the construction of condominiums. The street sign for the ferry queue remains as a reminder of the past. The harbor side of Front Street reveals remnants of the ferry waiting room, the Amboy Launch Service, and the Harbor Light tavern.

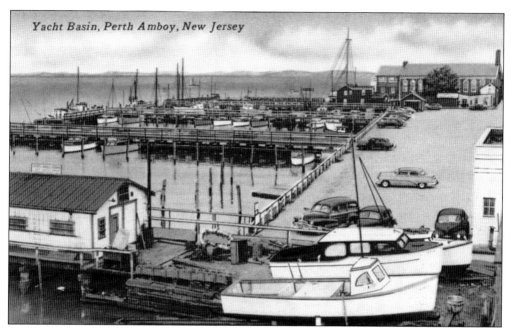

Yacht Basin, Perth Amboy, New Jersey

In this illustration, Perth Amboy's boat basin can be seen as it appeared in the middle of the 20th century, showing the southernmost public dockage on Front Street. The Raritan Yacht Club provided private dockage further south. Following years of damage from storms, tidal action, and usage, the facilities required replacement and modernization.

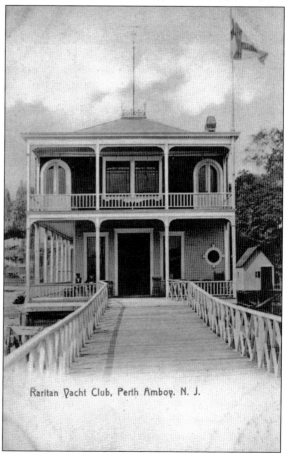

Raritan Yacht Club, Perth Amboy, N. J.

One of the oldest yacht clubs in America, the Raritan Yacht Club was originally organized in 1865 as the Carteret Boat Club. In 1882, these sailing enthusiasts joined another group, the Perth Amboy Yacht Club, to form the Raritan Yacht Club. This postcard shows the Raritan Yacht Club's impressive dockside entrance. The club's main activities were sailing, rowing, and racing.

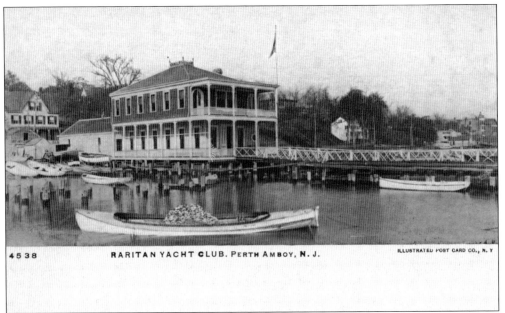

This view of the Raritan Yacht Club, at its third and current location on the Bluff on Water Street, shows its substantial growth. The land for the building on Water Street and the docks on Front Street was purchased in 1916 from the Cooper Estate after a fire had destroyed an earlier clubhouse. Sadly, most club records, paintings, ship models, and photographs were also destroyed.

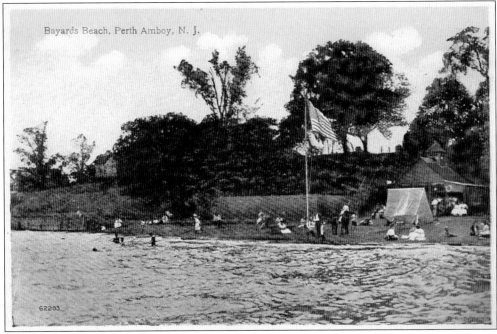

Bayard's Beach was located on the Arthur Kill, adjacent to the Cooper property that became the Raritan Yacht Club. A staircase led from Water Street down to the beach. Bayard's Beach was owned and operated by Capt. Samuel A. Bayard (1867–1924), who was the son of a Perth Amboy oysterman and lived and worked along the Perth Amboy waterfront his entire life.

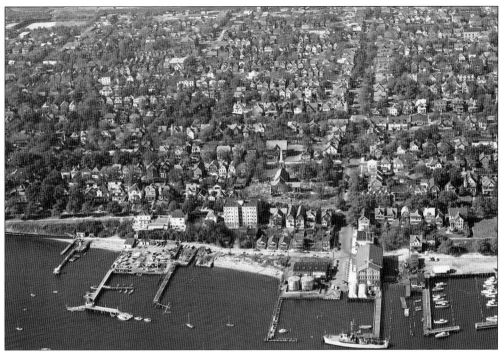

As Water Street climbs northward through the Bluff, it traverses a very scenic and richly historic section of the Waterfront. East of it are Bayard's Beach, Bayview Park, the marina, the Armory, and the Raritan Yacht Club. Directly west are St. Peter's Church and its graveyard, which dates to 1687. The present-day church building dates to 1849 and is in the National Register of Historic Places.

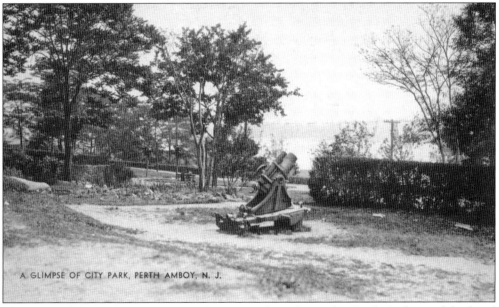

A GLIMPSE OF CITY PARK, PERTH AMBOY, N. J.

The captured German mortar seen in this postcard was donated to Perth Amboy and displayed in Bayview Park, between Water and Front Streets, in response to a 1919 request to the War Department from US representative Thomas Scully. It was intended to serve as a lasting reminder of World War I to the citizens of Perth Amboy.

As surplus armament became more available, several of Perth Amboy's public areas acquired various military weapons as decorations and reminders. The Gatling gun shown here was located on the stairs of Bayview Park, between Water and Front Streets. In one of the great unsolved mysteries of Perth Amboy, the gun vanished in the 1980s and has not been seen again.

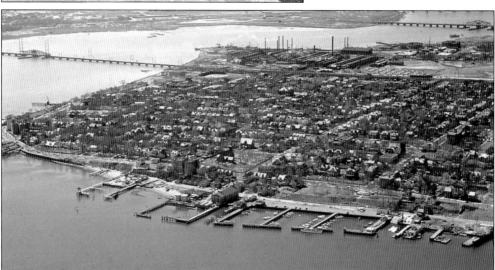

This 1950s aerial photograph of the eastern shore of Perth Amboy highlights many of the prominent landmarks in the southeastern part of the city. The peninsular nature of the town is evident in the photograph, with the confluence of the Arthur Kill to the east and Raritan Bay and the Raritan River to the South. In the foreground, the Armory, Bayview Park, St. Peter's Church, and City Hall are visible.

The intersection of High Street and Sadowski Parkway, on land, parallels the adjacent confluence of the Raritan River and Arthur Kill. From this point, Sadowski Parkway extends west to Second Street, while Water Street continues north to Smith Street. International Park, recently developed at the southern end of Caledonia Park, celebrates the multinational communities that have created and enhanced Perth Amboy.

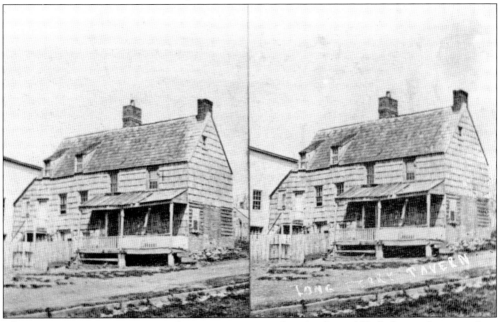

The Long Ferry Tavern, seen in this stereoview, stood at the foot of High Street. It was a place to meet and wait for the Long Ferry, Perth Amboy's first ferry, which initiated service to South Amboy around 1684. The Long Ferry Tavern, also built around 1684, was razed in the 19th century and was replaced by the Ashland Emery and Corundum Company.

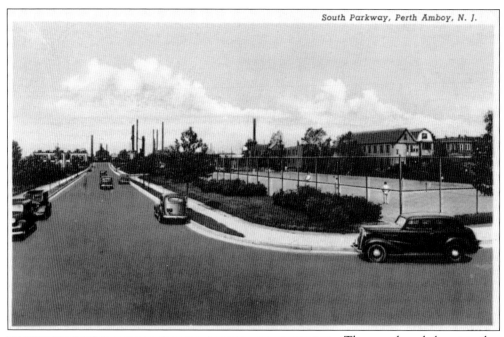

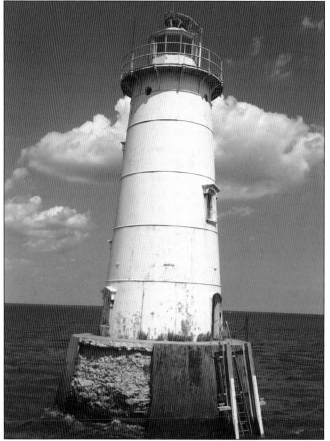

The paved road closest to the Raritan River provided early motorists a short scenic drive along the shoreline. The road, called both South Parkway and Raritan Parkway, offered views of the river and tennis courts. The road extended westward from Lewis Street to Second Street. The sewage plant and the Raritan Copper Works can be seen at the western end of the road.

Named after the oyster beds on which it was erected, the Great Beds Lighthouse was built in 1880 at the junction of the Arthur Kill and Raritan River channels, where it warned sailors of the shallow water and protected the oyster beds. In 1918, the frozen bay permitted pedestrians to visit the lighthouse, which was later automated in 1945. Later, in 2011, it was declared surplus and was sold.

44

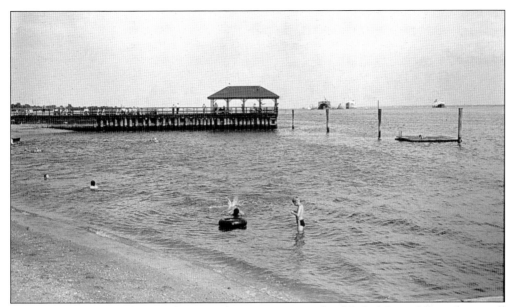

While some Perth Amboy residents can be seen enjoying the delightful weather as they stroll on the High Street pier, others are seen fishing from the pier, and others are swimming at the adjacent beach. The gazebo and pier have been replaced after several storms caused extensive damage. Ships can be seen anchored off the main channel.

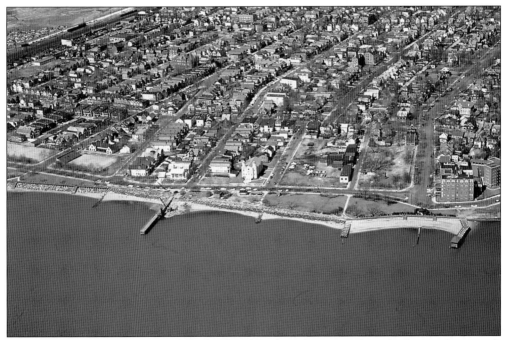

By 1956, Sadowski Parkway was a fully developed boulevard running along the Raritan River, with the city's boardwalk along its south side. Wide sandy beaches, fishing piers, green open spaces, and the Stand snack bar are visible. On the north side of Sadowski Parkway are the tennis courts, MacWilliam Stadium, and St. Demetrios Church. Sadowski Parkway ends at Caledonia Park and High Street, from where it continues as Water Street.

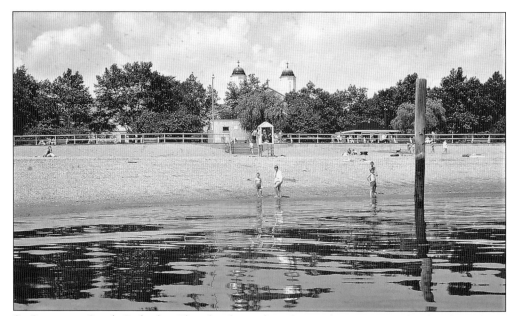

St. Demetrios Greek Orthodox Church is located on the northwest corner of Sadowski Parkway and Wisteria Street, where it is near the midpoint of Sadowski Parkway. Founded in 1917, St. Demetrios was one of the first Greek Orthodox churches in central New Jersey. It was across Sadowski Parkway from the Stand snack bar, which has been replaced by Perth Amboy's Veterans' War Memorial and Wall of Honor.

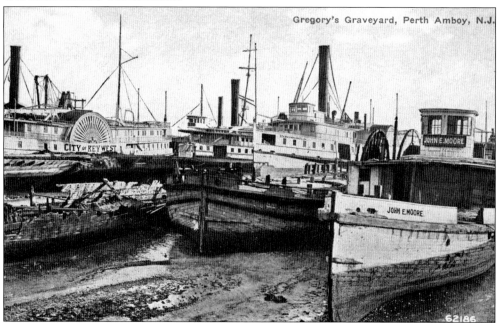

Gregory's ship graveyard was located on the Raritan River waterfront, near Brighton and Madison Avenues, before Sadowski Parkway was developed. Boats and ships of all sizes, from schooners to paddlewheel steamboats, were tied up or grounded at this location. The sidewheeler City of Key West is visible in this postcard. In the early 1900s, the city and the owners worked to relocate the deteriorating wreckage.

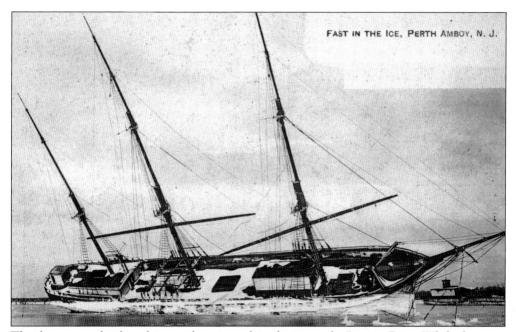

The three-masted sailing ship seen here is stuck in the ice on the Raritan River. While the exact date of this photograph is uncertain, there are documented accounts of the Raritan River and part of Raritan Bay freezing during the winter of 1917–1918. The ship appears headed east near the County Bridge. The Eagleswood tower can be seen north of the river.

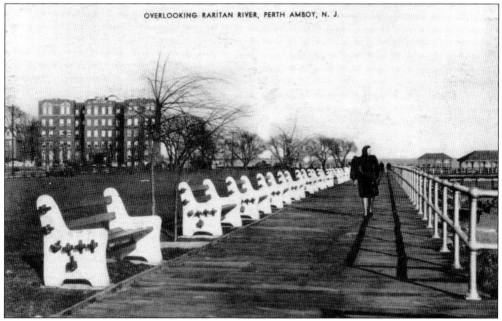

This view shows Perth Amboy's original boardwalk, looking east near High Street. Perth Amboy's Raritan River shoreline benefited from work done by the Work Progress Administration, which reclaimed the undeveloped land along the river in the 1930s to extend Raritan Parkway from Second Street to Water Street. The road was later renamed Sadowski Parkway in the 1940s in honor of Medal of Honor recipient Joseph J. Sadowski.

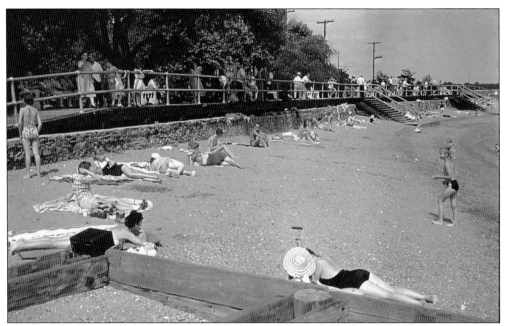

Perth Amboy's waterfront had many sections of beaches where bathers could enter the water. It was not until 1924 that the town began serious planning for the development of its beachfront and facilities. The leaders of the town wisely chose to avoid overdeveloping the area with arcades and permanent facilities. MacWilliam Stadium was a result of careful planning of the Wonderland property.

Tennis has been popular in Perth Amboy for decades, and many great players of the 1950s and 1960s enjoyed playing on the clay courts at the Tennis Club building on Sadowski Parkway between Catalpa and Brighton Avenues. The Tennis Club building has since been replaced by the Brighton Avenue Teen Center building, but city tennis courts still line Sadowski Parkway and remain open to residents.

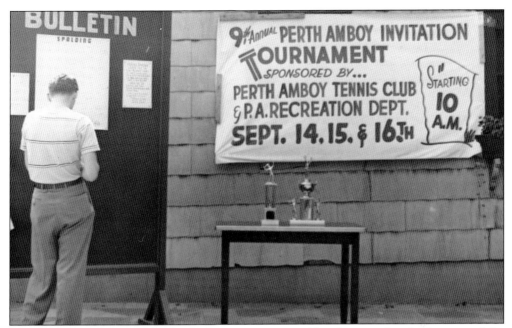

Perth Amboy had some of the finest clay tennis courts in New Jersey and took advantage of the situation to host a major national tournament. Local and national players competed, and tennis legend Arthur Ashe won the 1964 Perth Amboy Invitational Tournament. The Perth Amboy tournaments ended in 1965 when the US Lawn Tennis Association declared the city location too close to Forest Hills Stadium in Queens.

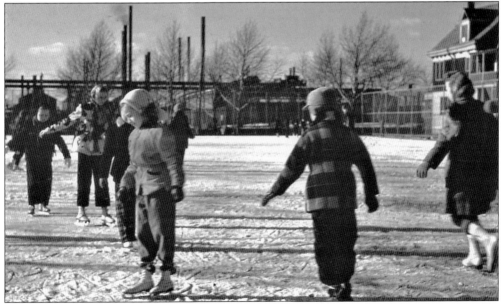

Adults, children, and families enjoyed ice skating during Perth Amboy winters, especially in the 1950s and 1960s, and it was customary for the city to flood and freeze the tennis courts along Sadowski Parkway to encourage and facilitate this activity. As seen in this photograph, taken in the 1950s, skaters enjoyed the convenience of practicing their skills close to home and without any pressure.

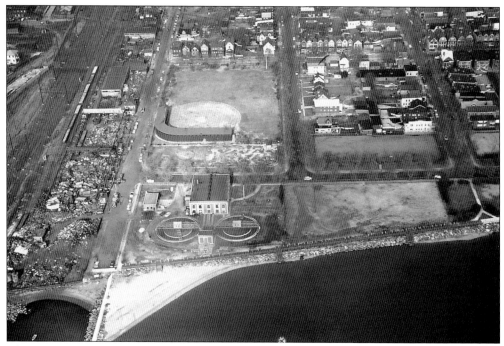

The western end of Sadowski Parkway includes MacWilliam Stadium and the adjacent vacant land, which later became a miniature golf course. In 2000, these were replaced by the Robert N. Wilentz Elementary School. The city sewage plant, completed in 1934, dominates the waterfront next to the small beach. On the left are Harry Goldberg and Sons Scrap Iron and the New York & Long Branch railroad tracks, approaching the train bridge.

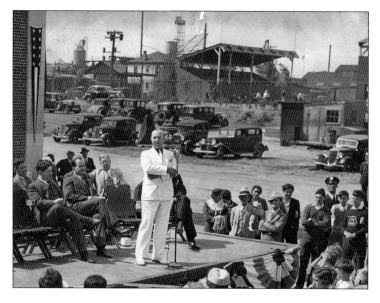

Many activities and facilities are seen at the western end of Sadowski Parkway, as city engineer Louis P. Booz Jr., dressed in a white suit, welcomes dignitaries to the dedication of the new sewage plant in 1934. Behind them, a baseball game is in progress at MacWilliam Stadium, where only the west grandstand has been completed. Across Second Street, work is underway at Goldberg's junkyard.

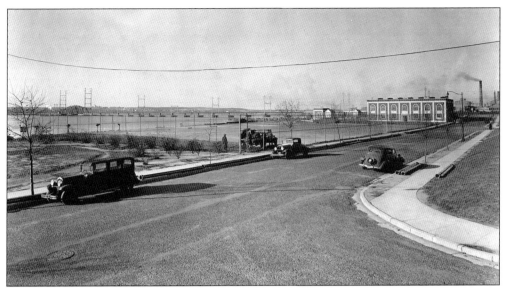

The fenced vacant land east of the sewage plant on Sadowski Parkway was used by baseball players who did not rate playing in MacWilliam Stadium. The field, known as "the Cages," featured a dirt and stone playing surface and a short right field. Left-handed batters occasionally hit "river shots" into the Raritan, which could be retrieved at low tide.

Located at the western end of Sadowski Parkway, between First and Second Streets, MacWilliam Stadium hosts a faculty-student baseball game. The stadium was built on the former Wonderland Park tract near the Raritan River, and it was named after J. Lockwood MacWilliam, a star athlete at Perth Amboy High School who attended the US Military Academy at West Point. (IR.)

A hotly contested 1932 Perth Amboy High School student-faculty baseball game at MacWilliam stadium attracted an overflow crowd. The runner crossing home plate is Gordon Koehler, a well-known teacher and tennis coach. Visible behind the grandstand is Harry Goldberg's junkyard, home of the original "junkyard dogs" security force and known as the "point of no return" for foul balls. (IR.)

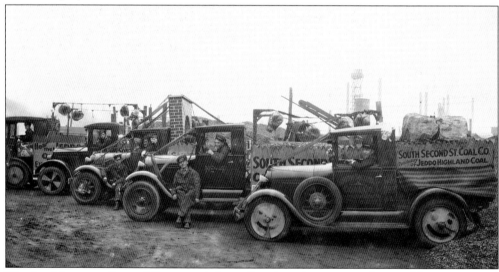

The land between Second Street and the railroad tracks contained several businesses and industries. In the 1950s, the southwestern corner of Market and Second Streets had a White Castle. Farther south were a plumbing company, a junk storage firm, and the South Second Street Coal Company, which is shown here. (GB.)

Three

ECONOMIC ENGINE
SMITH STREET
BUSINESS NEIGHBORHOOD

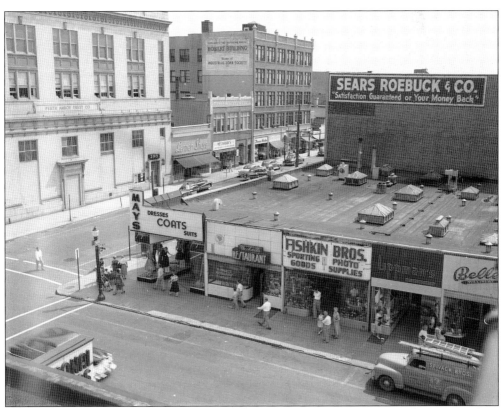

Near the center of the Smith Street business district, the bustling corner of Smith and Hobart Streets had something for everyone. Many retail businesses are visible in this 1946 view from F.W. Woolworth Company, including the original Fishkin Brothers, Mays, Michael's Restaurant, Lerner Shops, Mechanik's, Sarah Bardin, Thomas Studios, and Sears, Roebuck and Co., as well as the Hobart Building and the Perth Amboy Trust Company Building.

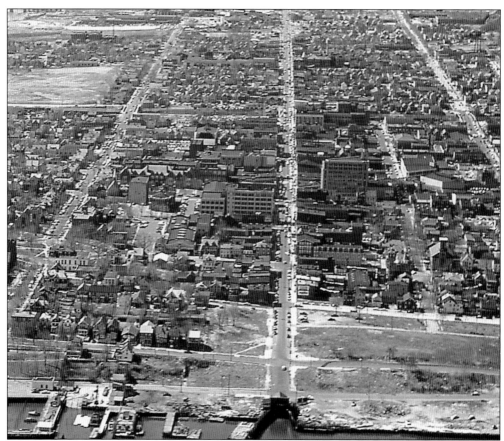

This aerial view of Smith Street, looking west, highlights its reputation as the "grand boulevard" of Perth Amboy. Visitors, arriving from the ferry, passed many retail businesses to reach "downtown" at the "Five Corners." Perth Amboy National Bank, Perth Amboy High School, No. 1 School, and the train station are visible in the business district. The waterfront buildings are gone, clearing the way for Harbor Terrace apartments.

The Smith Street neighborhood is in the southeastern part of the city. It extends from Fayette Street on the north to Market Street and slightly north of Market Street on the south and from the Arthur Kill on the east to the tracks of the Pennsylvania Railroad and Central Railroad of New Jersey on the west.

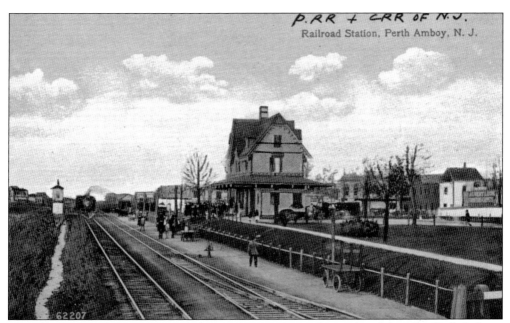

This illustration of the Perth Amboy train station shows the tracks of the New York & Long Branch Railroad (a joint venture of the Pennsylvania and the Jersey Central) running at street level through the city. Following an accident in June 1921, when a speeding fire truck was hit by a train and nine firemen were killed, authorities recognized the need to eliminate the grade crossings.

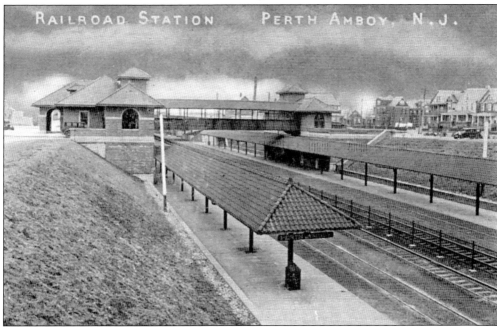

When the railroads and Perth Amboy relocated tracks and built bridges to eliminate grade crossings on all the active train lines, a new station was built in 1927. The station remained at street level while the tracks were depressed below grade, allowing passengers safe and direct access to both Smith and Market Streets. A unique feature was the pedestrian bridge that connected both northbound and southbound waiting rooms.

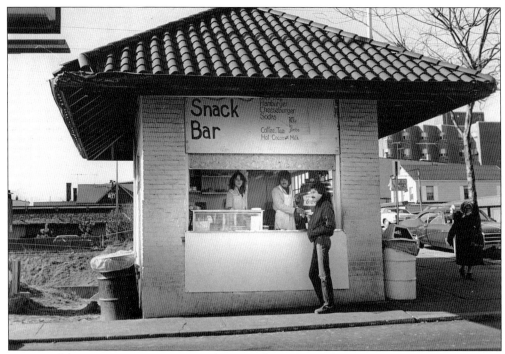

As part of the new train station, a matching small snack stand was located at the Smith Street stairway to northbound trains. Operated by generations of the Costa family, the stand started out serving coffee and newspapers to morning commuters. Although newspapers and french fries are gone, the hot dogs offered here in 1968 are still a featured part of the daily lunch menu.

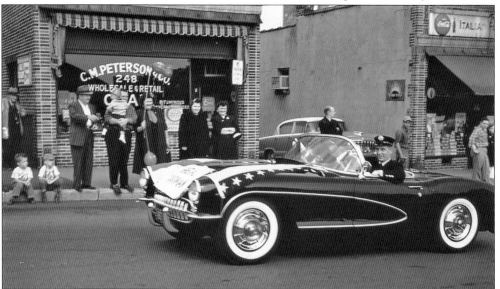

Perth Amboy residents loved parades, and holidays and sports victories provided opportunities to have them. Parades began at the ferry slip, Waters Stadium, or somewhere between, and the best viewing spots were at Smith and State Streets and Amboy and Hall Avenues. This parade features a 1956 Corvette that is passing the Peterson Coal Company as it approaches the Smith Street train bridge.

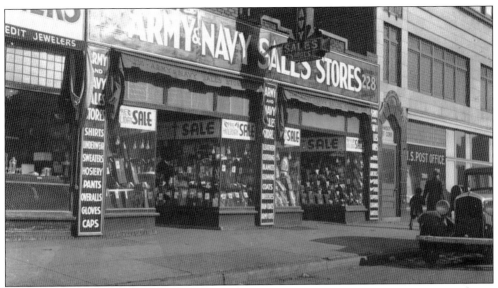

The Army-Navy Sales Store, located on Smith Street slightly west of Maple Street, was originally owned by Herman Stein, who also owned the Army-Navy Store at the corner of State and Jefferson Streets, and was later owned by Thomas Hoffman. Men who worked in Perth Amboy's industries, at the docks, or on arriving ships bought their work clothes at the store. (Courtesy of Norma Stein Witkin.)

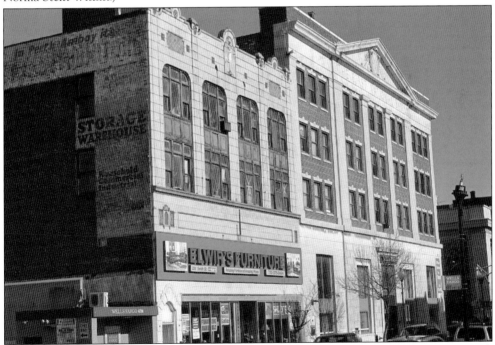

The Canadian Furniture building was adjacent to the First National Bank building on Smith Street. Many businesses called it home, and traces of their advertising signs remain on the wall. Tenants have included a supermarket, the post office, and Elwir's Furniture. The statue on the frontispiece of the building is part of the locally created terra-cotta architecture that is typical of many of Perth Amboy's commercial buildings.

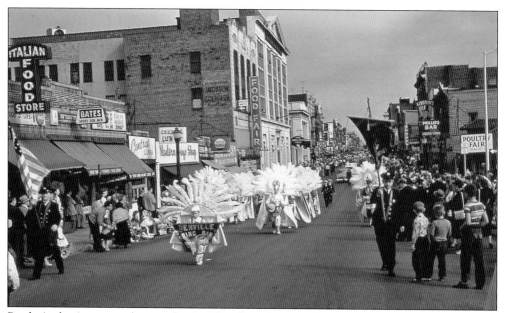

Perth Amboy's spectacular parades drew bands and groups from all over New Jersey, in addition to spectators lining the streets. The marchers here have just crossed Maple Street and are heading west on Smith Street. They are undoubtedly impressed by the city's commercial district, with First Bank and Trust Company, Food Fair, Army-Navy Store, Modern Boys Shop, Central Lunch, Bates, Poultry Fair, and Phillips Liquor Store lining the route.

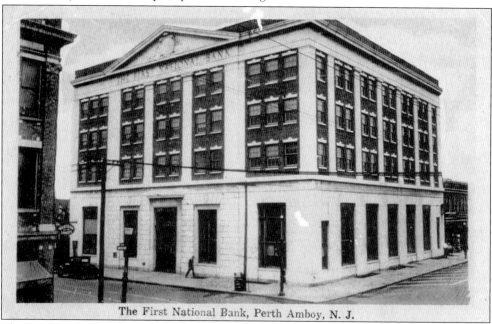

The First National Bank, Perth Amboy, N. J.

The First National Bank was located on the northwest corner of Smith and Maple Streets, across from the Perth Amboy Savings Institution. Its building was specifically designed in a colonial theme, to keep with the historic nature of the city. The bank, which had been in business for many years in a smaller, 19th-century building, followed its commercial customers as the city expanded westward.

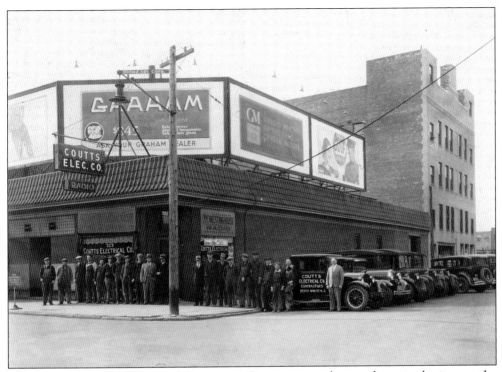

The Coutts Electric and Electrical Contractors Company was a large and growing business at the corner of Maple and Jefferson Streets. The employees proudly lined up on the southwest corner of Maple and Jefferson Streets. As the city grew and Smith Street power was relocated underground, the demand for both commercial and residential electrical supplies soared.

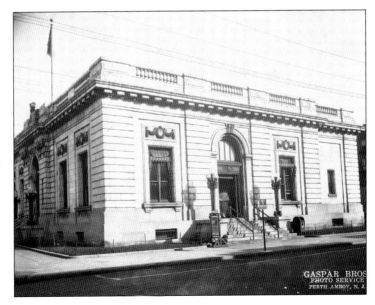

The new Federal Building and Customs House opened in 1906 when it relocated from the Flat Iron Building on State Street to the southeast corner of Maple and Jefferson Streets. As the customs office for the Port of Perth Amboy, it collected the tariffs on imported taxed goods. Perth Amboy was second to only Newark in collecting tariffs during the early part of the 20th century. (GB.)

59

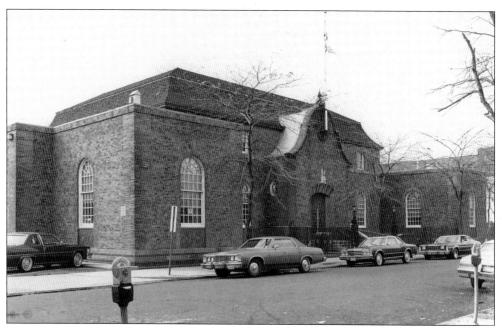

To meet the city's growth and need for increased postal service, a new post office was built at the site of the Federal Building and Customs House at Maple and Jefferson Streets. It was funded by the Treasury Department as part of Pres. Franklin Roosevelt's New Deal. The new facility opened in 1941, replacing several prior temporary locations for Perth Amboy's post office on Smith and State Streets.

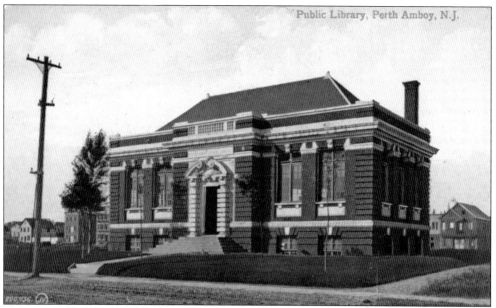

Public Library, Perth Amboy, N.J.

Incorporated in 1896 and opened in 1903, the Perth Amboy Free Public Library was erected with a grant from the Carnegie Foundation on land donated by C.J. McCoy. Two reading rooms were added in 1914; a children's library, built in 1925, was destroyed by fire in 1977. The library was restored in 2020 and has received a certification of eligibility for the National Register of Historic Places.

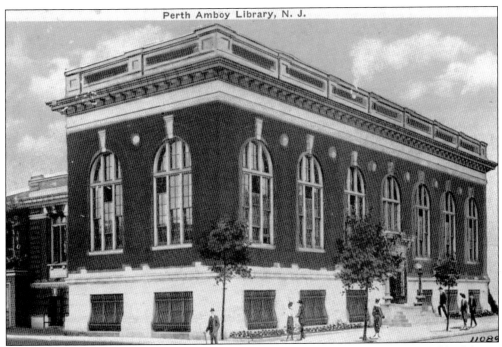

The Perth Amboy Free Public Library is affiliated with the Middlesex County Public Library System, and it continues to evolve to meet the needs of the community. Located on Jefferson Street, between Maple Street and Madison Avenue, the building has expanded greatly from its original size. To meet the future needs of the community, additional expansion is planned.

Grace Lutheran Church was first built in 1903 on Jefferson Street, across from the library. Pictured is the Golden Jubilee of the parish and the retirement of its priest in 1953. With members residing in both Perth Amboy and Fords, a new church was built in 1957 on New Brunswick Avenue, slightly west of Convery Boulevard. The original church on Jefferson Street was replaced by a parking lot.

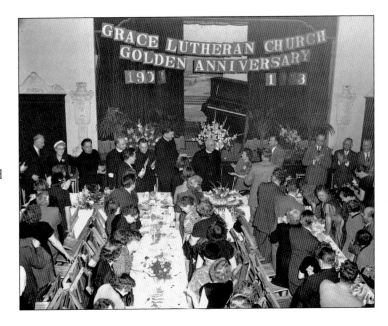

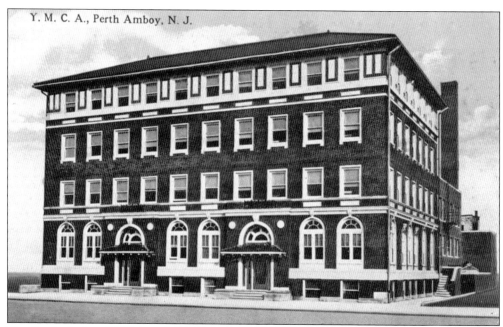

The Perth Amboy YMCA on Jefferson Street was chartered in 1912 and built in 1913, after a successful fundraising effort. The building housed a swimming pool, locker rooms, a gymnasium, meeting rooms, and lodging for men. Although this facility was destroyed by fire in 1997, many of its programs are offered by the Raritan Bay Area YMCA on New Brunswick Avenue.

The City of Perth Amboy celebrated the 275th anniversary of its founding in 1958 with a spectacular street festival. One of the highlights of that event involved laying large sheets of linoleum on Smith Street, converting the main shopping street into a mall. Looking eastward on Smith Street, from the corner of McClellan Street, it appears that many of the stores had prepared special sales in anticipation of the event.

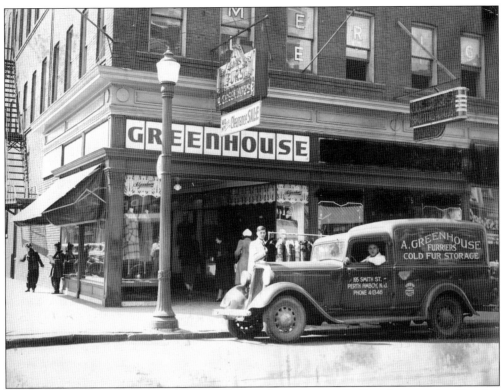

Before immigrating to America in 1909, Abe Greenhouse was a tallit (Jewish prayer shawl) maker in Poland and then was a tailor in North Jersey before moving to Perth Amboy in 1914. His fur store, A. Greenhouse Furs, opened on Smith Street near the ferry slip and later relocated to the corner of Smith and McClellan Streets, where it served the community for several decades. (Courtesy of Muriel Brandwein Greenhouse.)

The second Royal Theatre was near the corner of Smith Street and Madison Avenue. It was the last of the theater and movie houses that occupied the Smith Street premises. In 1916, the location was known as the City Theatre, renamed the Liberty, and in 1920, the Crescent. It was renamed the Royal in the early 1950s. It featured less-known movies and reruns.

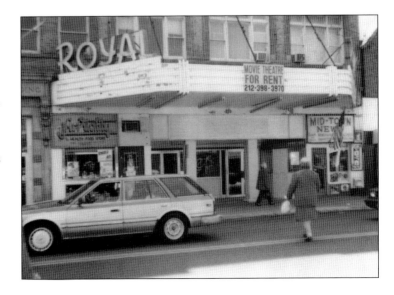

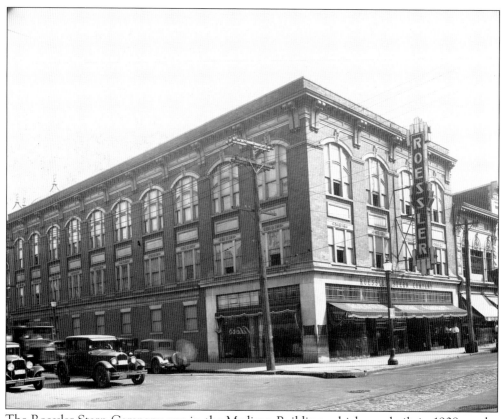

The Roessler Stern Company was in the Madison Building, which was built in 1908 on the northeast corner of Smith Street and Madison Avenue. This was a furniture store with showrooms on the main floor, and the building was later renovated for many other commercial tenants. In 1975, the building was destroyed by a fire that started in the basement and spread to the Shaarey Tefiloh synagogue. (GB.)

Perth Amboy spectators fill Smith Street, watching the unloading of a Whippet tank in front of the Albert Leon Furniture Store on April 24, 1919. The Whippet tank had been successfully used by American troops in France during World War I. Albert Leon was instrumental in arranging this event as part of the Victory Liberty Loan Campaign, a national fundraising drive in which Perth Amboy citizens contributed to its success.

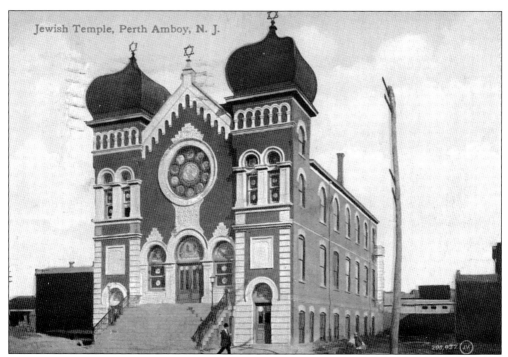

Jewish Temple, Perth Amboy, N. J.

In 1903, the impressive Shaarey Tefiloh Synagogue ("Gates of Prayer") was built on Madison Avenue, where it served the Orthodox Jewish Community until it was destroyed by a fire in 1975. Most members of the synagogue were of Eastern European descent, and they were very actively involved in all aspects of Perth Amboy's community as businessmen, professionals, and community leaders. Most of their children attended Perth Amboy's public schools.

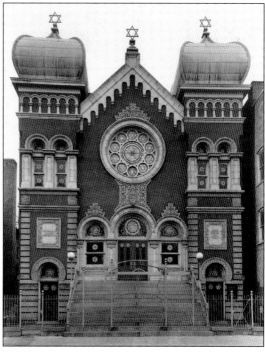

Shaarey Tefiloh synagogue was an imposing Byzantine structure that was often described as one of the most beautiful of its kind in the western hemisphere. It was an ornate structure that continuously served Perth Amboy's Orthodox Jewish Community from 1903 until its destruction in 1975, when a fire spread from a nearby department store. Many Christians joined Jews in rescuing sacred religious objects from the synagogue. (Courtesy of Burton Sher.)

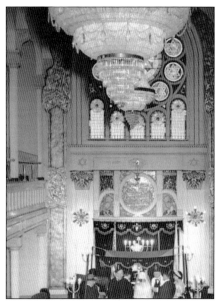

While the synagogue served as a religious and spiritual home to the Orthodox Jewish community, Shaarey Tefiloh's magnificent interior enhanced its desirability as a venue for weddings and other important life-cycle events. The very ornate and elegant interior can be seen in this 1949 wedding photograph of Charney Madrazo and Herb Pologe, which reveals beautiful stained-glass windows and religious artwork. (Courtesy of Charney Madrazo Herst.)

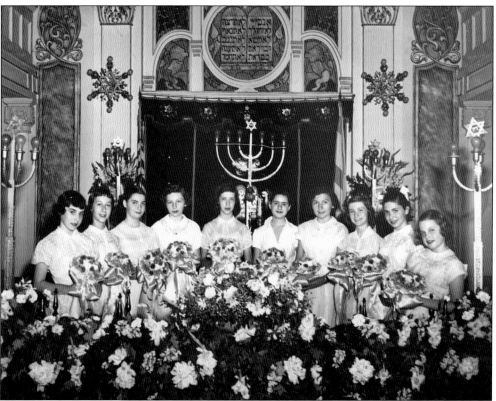

In this June 1952 photograph, the Bat Mitzvah class at Congregation Shaarey Tefiloh stands on the raised platform at the front of the synagogue, facing the congregation. Behind these girls are the ark, containing the Torahs, and beautiful stained-glass windows featuring religious symbols, including the Ten Commandments. This group confirmation ceremony was held every June for the class of 13-year-old girls. (Courtesy of Bertha Faffer James.)

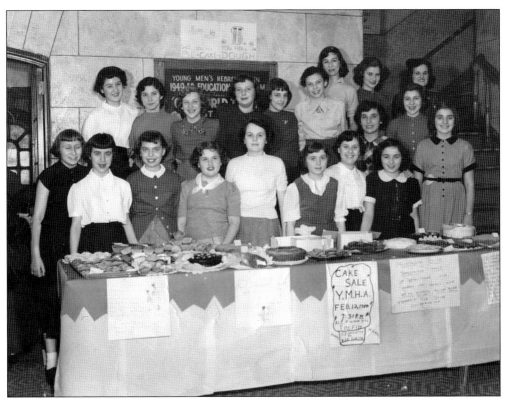

Built in 1923 at Madison Avenue and Jefferson Street, the Young Men's Hebrew Association (YMHA) was the center of social and athletic activities for the Jewish community until the building was destroyed by fire in 1975. This 1950 bake sale was one of many events that took place at this busy center, which had a gym, pool, auditorium, meeting rooms, classrooms, and roof garden. (Courtesy of Marilyn Millet Goldberg.)

The Perth Amboy YMHA was home to many athletic teams, with basketball the most popular sport. Many Perth Amboy YMHA basketball teams were community and state champions, including the 1936 New Jersey State YMHA Championship team in this photograph, which was autographed by all the proud members of that team. The YMHA gym also welcomed athletes of all abilities and in many different sports. (Courtesy of Amy Sussman Shearer.)

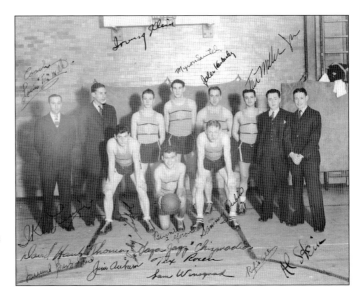

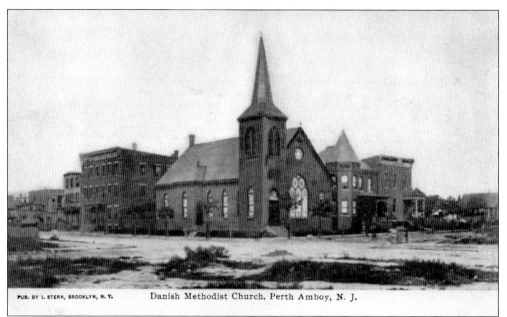

Danish Methodist Church, Perth Amboy, N. J.

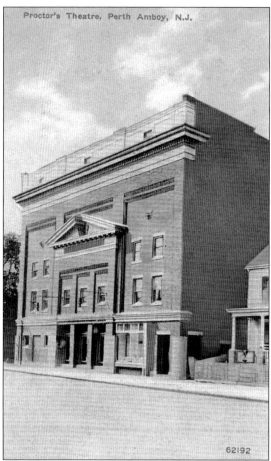

Proctor's Theatre, Perth Amboy, N.J.

62192

The Danish Methodist Church on the northeast corner of Madison Avenue and Jefferson Street was dedicated in 1899. In 1942, the church was reincorporated as the Wesley Methodist Church. After partial destruction by fire in the 1950s, the building was purchased by Congregation Beth Israel in 1959 and converted into an Orthodox Jewish synagogue. With a declining congregation, the building was sold to Temple Church in 1981.

Perth Amboy was a known theater town in the early 1900s, with Proctor's Theatre on Madison Avenue the primary home of legitimate theater. With a small capacity house, but one of the largest stages, it accommodated a variety of performances, graduations, and civic events. Perth Amboy audiences were "tough and critical." The city's location near New York City's Broadway gave Perth Amboy "theater town" status.

When the Hotel Madison opened in 1913, it advertised itself as a first-class facility, comparable to any in the state. Its location across Madison Avenue from Proctor's Theatre provided a steady supply of guests for the hotel. As live theater in Perth Amboy transitioned to motion pictures, there were not enough theatergoers and performers to meet the hotel's operating costs, and the hotel was forced to close in 1928.

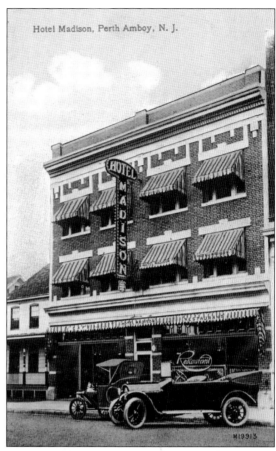

Hotel Madison, Perth Amboy, N. J.

The Majestic Theatre took over Proctor's Theatre in August 1924. It continued legitimate theater and vaudeville acts but switched to predominantly screen presentations as the motion picture revolution began. The theater became part of the Walter Reade Organization, which remodeled it several times. The Majestic succumbed to the decline in viewers and was sold in 1990 to the Second Baptist Church, renamed Cathedral International.

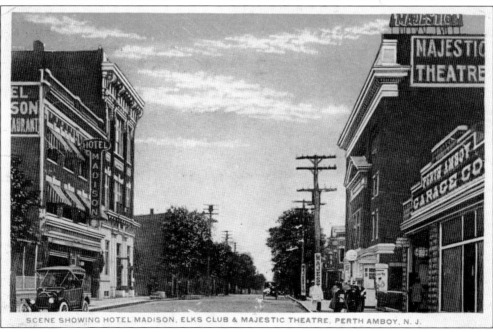

SCENE SHOWING HOTEL MADISON, ELKS CLUB & MAJESTIC THEATRE, PERTH AMBOY, N. J.

69

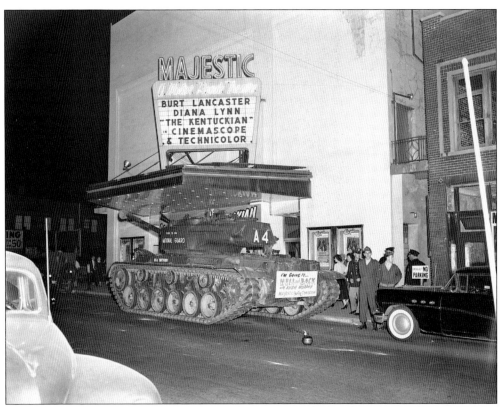

Many theaters used innovative methods to attract viewers during the post–Korean War movie-going slump of the 1950s. With *The Kentuckian* playing at the Majestic in August 1955 (as listed on the marquee), this M-47 Patton Tank was placed in front of the theater on Madison Avenue to promote *To Hell and Back*, which starred Congressional Medal of Honor winner Audie Murphy playing himself.

Coutts Electrical Supply was first located at 260 Madison Avenue. It was a full-service retail and commercial electrical supply house that provided the consumer with everything electrical for the home, from the table lamps and chandeliers seen in this window display to radios and appliances. They also did contract electrical work for the city, the board of education, and local industries at the dawn of the electric power revolution.

Located conveniently on Smith Street between Madison Avenue and State Street, the upscale-looking Reynolds store was a favorite clothes-shopping destination for the entire family. This 1959 photograph shows one man and many women wearing attire from an earlier era, as they participate in one of the store's special events. The store also had a "fashion advisory board" for high school girls, who participated in frequent fashion shows. (PAFPL.)

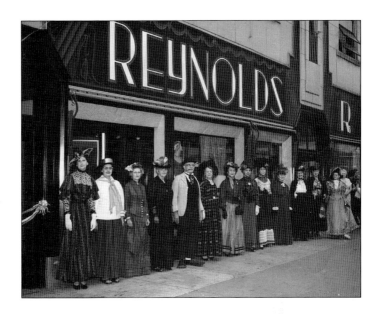

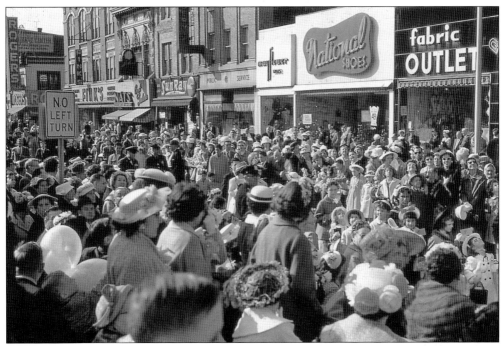

Smith Street was always busy since it featured so many wonderful stores, such as Roger's Clothes, Fink's, Nats, Sun Ray Drugs, Public Service, Mayflower, National Shoes, and Fabric Outlet. However, weekday crowds were no match for the 1960 Easter Parade, for which Smith Street was closed to vehicular traffic. Attendees walked past a reviewing stand of judges wearing their Easter clothes and hats, hopeful of winning a prize.

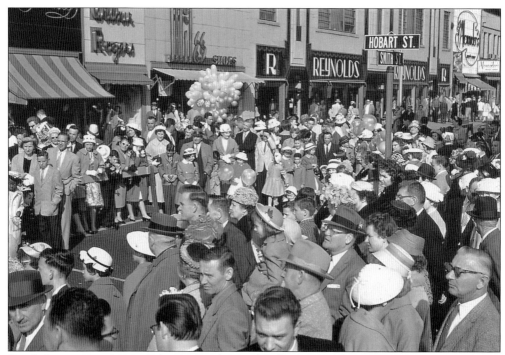

Smith Street was a shopper's dream. On the north side were Woolworth's, Wilbur Rogers, Miles, Reynolds, and Alexander's. On the south side were Lippman's, Fishkin Brothers, Paramount, Slobodien Shoes, Belle, Michael's, May's, and Lerner Shops. The 1960 Easter Parade attendees filled the entire street at the corner of Hobart Street, as well as for several blocks east and west.

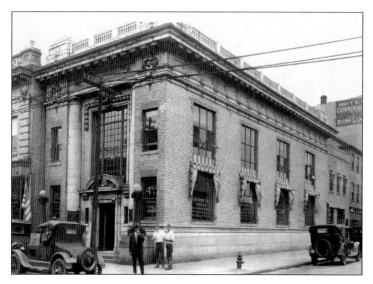

The Perth Amboy Trust Company was incorporated in March 1902 and opened for business in October 1902. The stockholders and officers of the bank were industrialists and leading businessmen of the city, fueling the bank's rapid growth. Soon, in 1904, the company erected a spacious one-story building on the southeast corner of Smith and Hobart Streets.

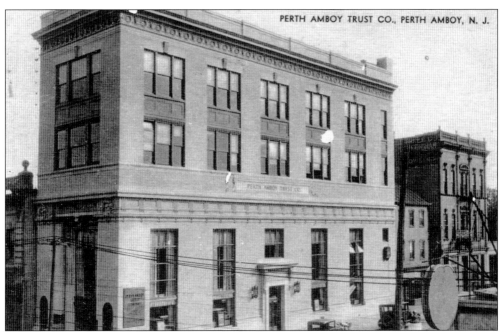

The Perth Amboy Trust Company Building renovation in 1917 featured a remarkably well-done second-floor addition. Unfortunately, solvency rumors started in the early 1920s, and the trust company merged with the City National Bank in 1923. The failed bank was closed in 1937, and the first floor subsequently housed a shoe store, a women's dress shop, and a pharmacy. The bank's name remains inscribed in the stone and on a plaque.

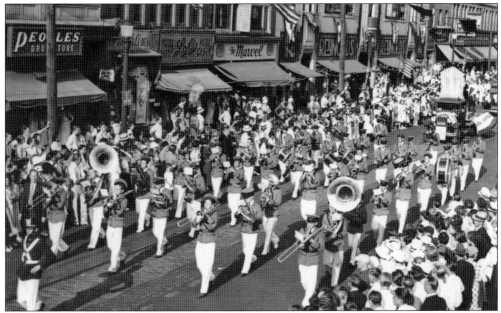

Perth Amboy's parades included plenty of bands. The many flags decorating the street, storefronts, and floats suggest the occasion is a national holiday. Both the attire and the trolley tracks in the Smith Street paver blocks suggest that this photograph was taken in the early 1940s. Crowds lining the streets were typical for Perth Amboy parades.

Leaders and members of Congregation Shaarey Tefiloh march in a celebratory parade on Smith Street in 1976, carrying the Torahs that had been heroically rescued from the fire that had destroyed the previous synagogue on Madison Avenue to the new Shaarey Tefiloh Synagogue on Market Street. Both Jews and their Christian friends and neighbors participated in this celebration. (JHSCJ.)

Perth Amboy was ahead of the curve in the late 1950s when the city erected "Season's Greetings" banners on Smith Street during the holiday season. A familiar downtown sight was the police officer risking his life at the "Five Corners" intersection of Smith Street, New Brunswick Avenue, and State Street. Thankfully, the city saw the safety problem and installed concrete barriers to insure a "Safe Haven" for pedestrians.

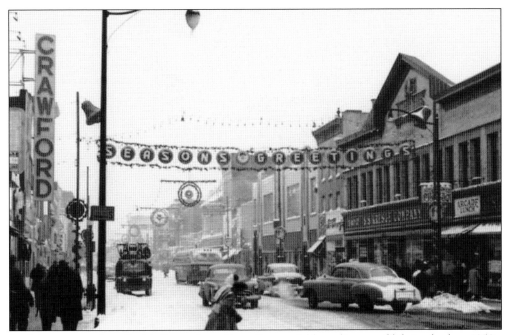

Looking westward on Smith Street from State Street yields a glimpse of life in the late 1950s. The holiday decorations appeared every November and were often accompanied by snow, as seen here. The north side of Smith Street is dominated by the S.S. Kresge Company, and shoppers can be seen entering and leaving the store, undaunted by the snow.

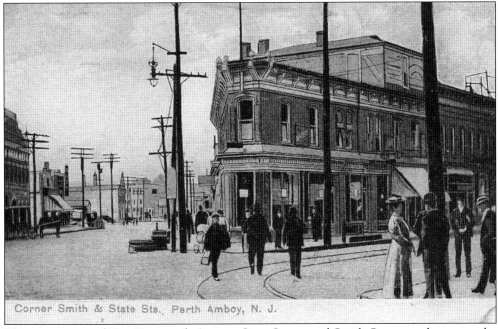

Corner Smith & State Sts., Perth Amboy, N. J.

The intersection of New Brunswick Avenue, State Street, and Smith Street was known as the Five Corners. Visible here is the triangular building on the northern corner. It was once the post office building and later the Flat Iron Building. It hosted many retail businesses before being razed in 1929 for the construction of the Perth Amboy National Bank.

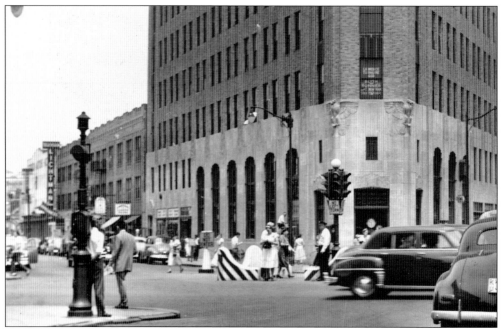

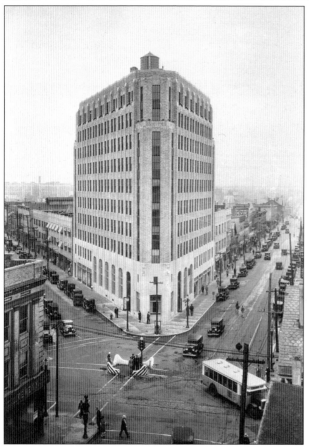

One of the most prominent landmarks in Perth Amboy, visible from many parts of the region and from the air, is the 10-story skyscraper, best known as the Perth Amboy National Bank Building. Built in 1930, the building was first occupied in 1931. The bank occupied the first floor, and upper-floor offices were leased to various professionals. The building is currently owned by ETC Management Inc., a property-leasing company.

The Perth Amboy National Bank building continues to anchor the Five Corners intersection. Although the ground floor is currently vacant, the building's upper floors are leased by several professional offices. To visitors waiting for an elevator, the Art Deco lobby serves as a reminder of the building's appearance when it opened in 1931. (GB.)

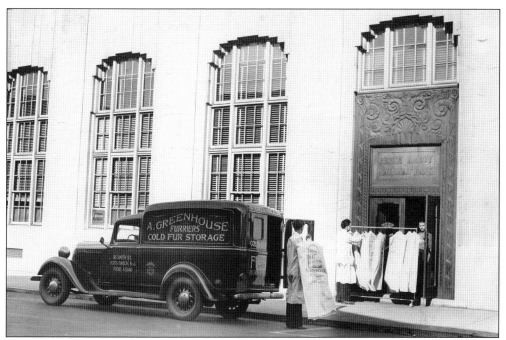

In addition to selling furs, A. Greenhouse Furriers, owned by Abe Greenhouse, provided ongoing care for its customers' furs, including cold storage at the nearby Perth Amboy National Bank, pictured in this photograph. A man of many talents, furrier Abe Greenhouse was also a famous artist, whose eggshell mosaics were widely coveted and occasionally displayed at the Smithsonian Institution. (Courtesy of Muriel Brandwein Greenhouse.)

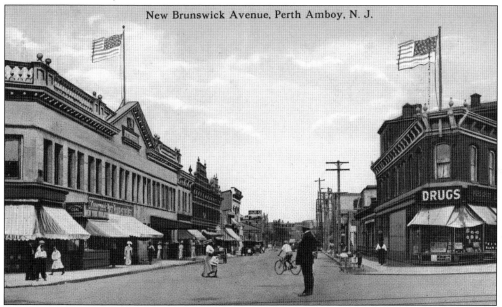

The two-block section of New Brunswick Avenue shown in this illustration, as it extends from the Five Corners intersection, was a very busy part of the business district in the early 1900s. The Bijou Theatre can be seen, as well as several food stores and a drug store. A classic traffic cop stands in the street, prior to the installation of protective barriers.

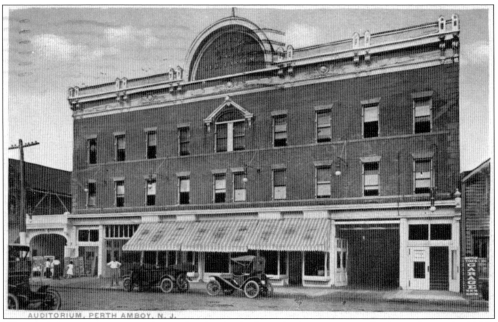

AUDITORIUM, PERTH AMBOY, N. J.

The city's big-time sports palace, the Perth Amboy Auditorium, was built in the early 1900s on New Brunswick Avenue near Jefferson Street. It held crowds of 2,000 spectators for boxing matches, basketball games, plays, conventions, and dances. It was filled to capacity when Gov. Woodrow Wilson spoke there during his 1912 campaign for the presidency. The building became a car dealership in its final years and was razed in 1971.

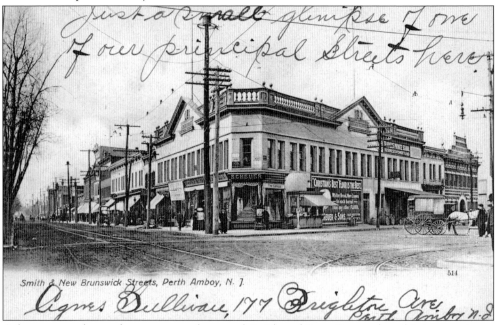

Smith & New Brunswick Streets, Perth Amboy, N. J.

A few trees on the southwest corner of unpaved Smith and State Streets date this image prior to 1911. The Scheuer and Sons grocery building dominates the northwest corner of Smith Street and New Brunswick Avenue. The city stables are north of the intersection, next to the Scheuer building. Both Smith Street and New Brunswick Avenue were paved soon afterward.

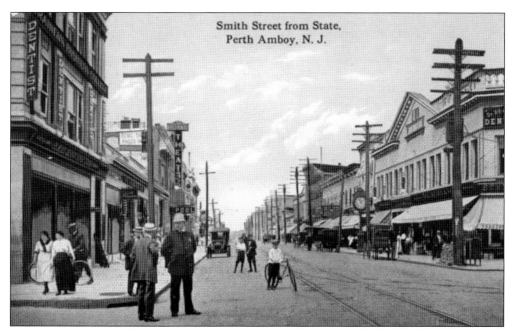

This illustration of Smith Street, looking west from State Street, gives a glimpse of the area in the early decades of the 20th century. One prominent building is the Royal Theatre. Unlike the future namesake, this theater was a movie house that opened in 1911 and had a short life span. In its later years, it was used only for special events until it closed in 1920.

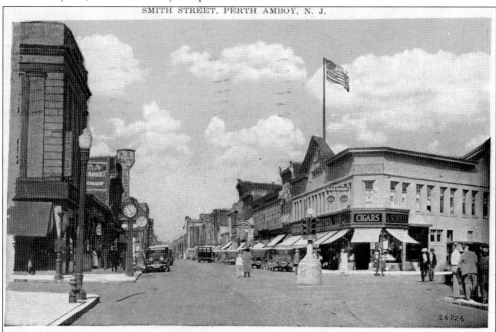

In this westward-looking illustration of Smith Street from State Street in the 1920s, the P.A. City Market, a grocery store, has replaced the Royal Theatre on the south side of Smith Street. Several professional offices are noted on the upper floors of buildings on both sides of Smith Street, and the artist suggests significant development west of this area.

The Buchanan house stood on the busy southwest corner of Smith and State Streets in this 1904 photograph. Capt. William Buchanan was a well-known oysterman in Perth Amboy, who lived in the house from the mid-1860s until it was sold in 1910 to permit the construction of the American Building. The trees lining Smith Street also appear in an early illustration of the same area. (Courtesy of Mary Ellen Pavlovsky.)

This 1912 photograph of the Buchanan houses at Smith and State Streets was taken prior to their relocation to Paterson Street and Brighton Avenue. Across Smith Street from the Buchanan houses is the Scheuer and Sons grocery building on the northwest corner of the Five Corners, where it was bordered by Smith Street and New Brunswick Avenue. (Photograph by J. Lawrence Boggs, Jr., courtesy of Mary Ellen Pavlovsky.)

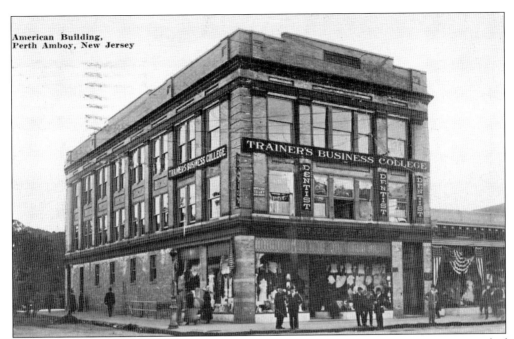

American Building,
Perth Amboy, New Jersey

TRAINER'S BUSINESS COLLEGE

The American Building, on the southwestern corner of Smith and State Streets, was typical of the mixed-use buildings that were built in the early part of the 20th century. The first floor had retail enterprises, while the upper two floors were leased as office space. One notable tenant was the Trainer's Business College, which offered post-baccalaureate business training, secretarial skills, and technical courses.

Perth Amboy's public high school was established in 1881, but its classes were not consolidated into a single building until 1899, when a school was built on an old cemetery and the Middlesex County Jail site on State Street. Soon covered in lush green ivy, the school became known as the "Halls of Ivy." The ivy remained until 1974, when the building was repurposed as the McGinnis Middle School.

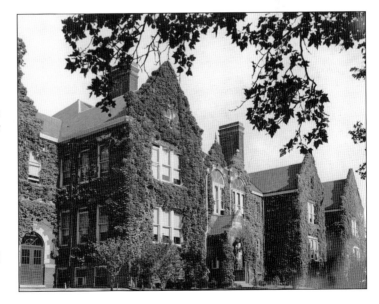

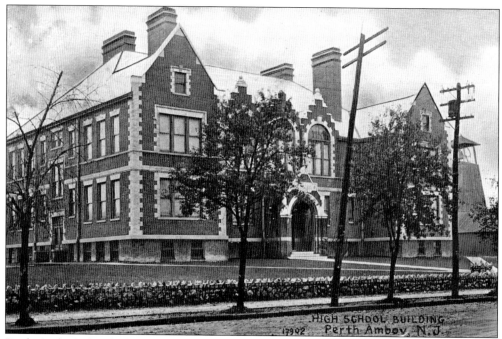

Perth Amboy's first high school classes were taught in Nos. 1 and 4 Schools, and high school students did not get their own school until Perth Amboy High School was built in 1899 and dedicated in 1900. Its first graduating class, in May 1900, had only nine students. The large auditorium facilitated future growth, and business classes were soon added to the curriculum.

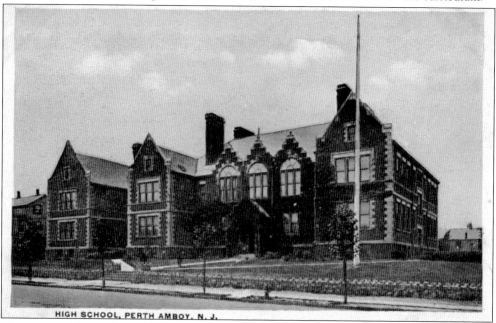

The city's rapid growth quickly created a need for more room at Perth Amboy High School, and a southern wing was added to the original building in 1911. Commercial courses were added to the curriculum to prepare students to enter business or industrial fields. In 1915 and 1923, two classroom additions were constructed behind the school.

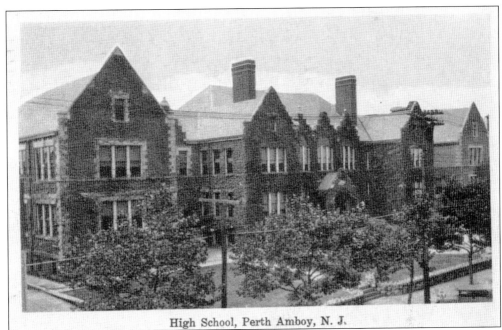

High School, Perth Amboy, N. J.

By 1930, Dr. William C. McGinnis had become superintendent of schools, and the high school had added a large section to the north side of the building. It featured an impressive gymnasium and manual training department, which represented expanded opportunities for the students. This was the fully-developed size of the building, as it appears in photographs and postcards from the midcentury.

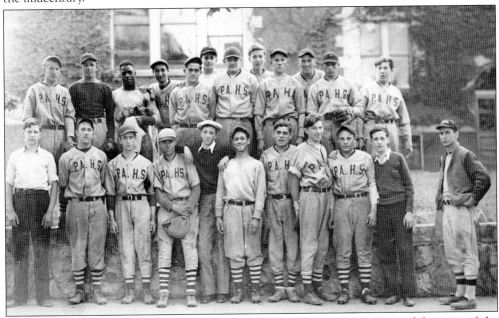

The 1932 Perth Amboy High School baseball team stands proudly in front of the steps of the Halls of Ivy on State Street. The only undefeated team in the state of New Jersey, they won the Monmouth-Middlesex League Championship. They were coached by future Perth Amboy physical education teacher and Rutgers star player Stanley "Tex" Rosen. (IR.)

The ivy-covered front of Perth Amboy High School, along with the grass lawn and shrubs, gave it the look of a university campus. No playgrounds or parking lots were allowed. The infamous sharp-edged stones set in the wall along State Street conveyed a strong "keep off the grass" message. Students waiting in the morning socialized along the sidewalk until the doors opened.

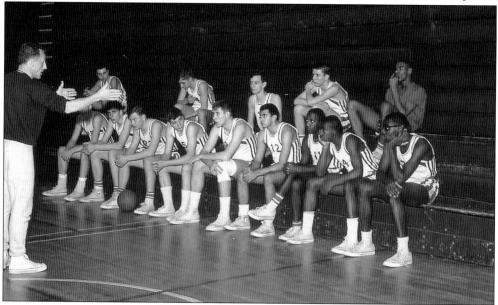

Coach Bill Buglovsky talks to his 1965 Perth Amboy High School basketball team during practice. This team played an up-tempo fast game and tore through area teams on its way to an undefeated 21-0 season. During the 1965 season, the team won two remarkable 100-point games, captured the Holiday Festival and Middlesex County Tournament, and ultimately suffered its only loss in the New Jersey State Tournament championship game.

While Perth Amboy High School's gym was usually filled with boys' basketball games and practices, boys' wrestling matches, girls' intramural sports, physical education classes, cheerleader practices, calisthenics, and gymnastics exhibitions, it was also used for proms and seasonal school dances. In this June 1964 photograph, seniors are excitedly decorating the gym for their senior prom, before rushing home to don their elegant attire.

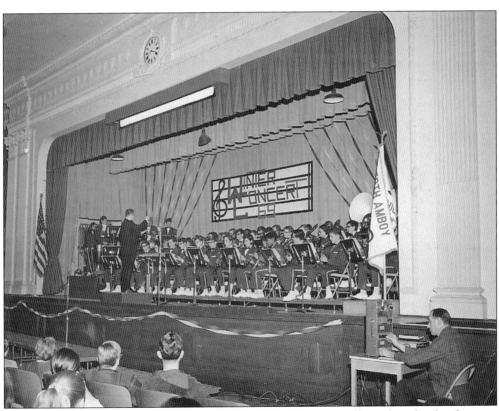

The Perth Amboy High School Concert Band held concerts annually in the school auditorium since 1941. This band concert was one of several annual concerts performed by the school's student musicians in the classic auditorium. Others, such as the Cavalcade of Music, featured the Girls' Chorus, Boys' Chorus, Selective Chorus, Orchestra, and Swing Band. All these performances were special events that required many hours of individual and group practice.

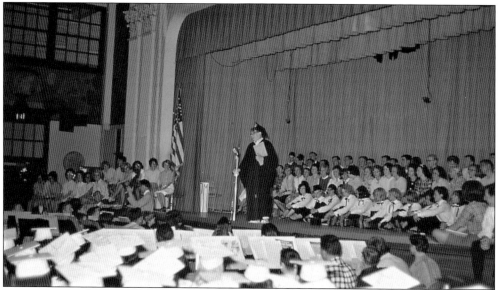

Perth Amboy High School's auditorium was used for many school events, including concerts, musicals, and student plays, as well as study halls. The theater-sized stage was large enough for any event, and the large windows flooded the room with natural light. Murals depicting arts and sciences were added to the walls in 1935–1938 and are currently being restored.

The march from Perth Amboy High School to the Majestic Theatre, where commencement exercises were held, was a traditional part of the event. In 1964, the ivy-covered walls, rosebush path, and English teacher Joseph Kerr guiding the class were all part of the memorable graduation experience. Signing yearbooks after the ceremony was a final tradition.

After walking from Perth Amboy High School toward the Majestic Theatre for commencement exercises, graduates await instruction from vice principal Patrick White before crossing Madison Avenue to enter the theater and begin the June 1964 ceremony. The traditional graduation march from the high school on State Street, along Market Street to Madison Avenue, and into the Majestic Theatre, was filled with pride and nostalgia for all participants.

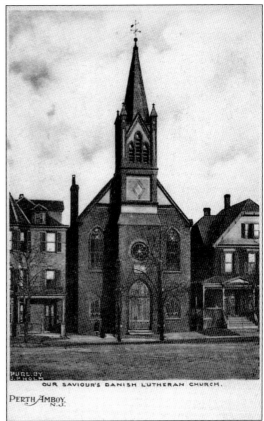

OUR SAVIOUR'S DANISH LUTHERAN CHURCH.
PERTH AMBOY, N.J.

Our Savior's Danish Lutheran Church of Perth Amboy adopted a constitution in 1896 and then quickly constructed this church for its rapidly-growing congregation near the northeast corner of State and Market Streets. Church services were conducted in Danish until 1925, when the church became known as Our Savior's Evangelical Lutheran Church. The congregation moved to Edison in the 1970s.

The Perth Amboy Board of Education was organized in 1870 and opened No. 1 School in 1871, on State Street between Market and Smith Streets. The city's rapid growth led to the school doubling in size by 1905. Thomas Mundy Peterson was the school's first custodian, and in 1989, the school was renamed in his honor. This historic building continues to function as a public school today.

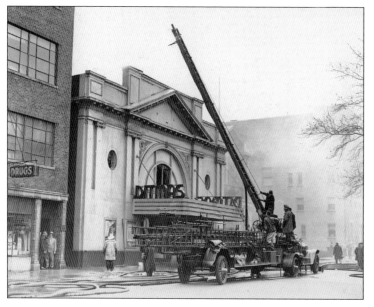

The Ditmas Theatre opened in 1914, adjacent to No. 1 School on State Street. With 780 seats and a single screen, it functioned primarily as a movie house. From 1917 to 1919, the theater also showed movies in its outdoor "Airdome," which had a screen mounted on the building's exterior wall and seats installed on an outdoor wooden platform. The theater was destroyed by fire in 1951.

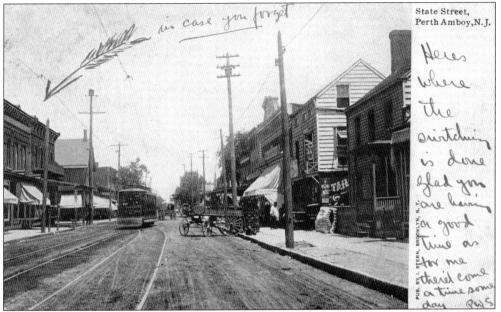

This 19th-century postcard illustration shows the many buildings that filled both sides of State Street. Since Smith Street did not grow westward until late in the first decade of the 20th century, the business district turned north on State Street, which featured many shops supplying the community. The postcard also shows the trolley switch at Jefferson Street on the Raritan Traction Company's State Street line.

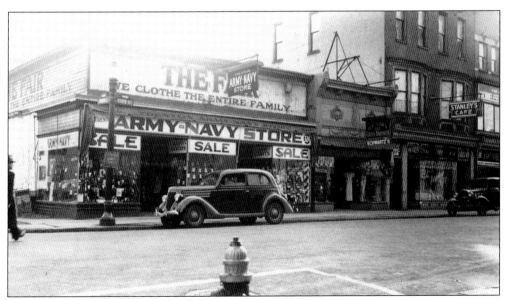

The Trenton Army-Navy Store, located at the corner of State and Jefferson Streets, was owned by Herman Stein, who relocated the store from Trenton to Perth Amboy in 1938. This store sold men's work clothes and had a variety of customers who worked on ships at Perth Amboy's docks, in the State Street heavy industries, and in local construction. (Courtesy of Norma Stein Witkin.)

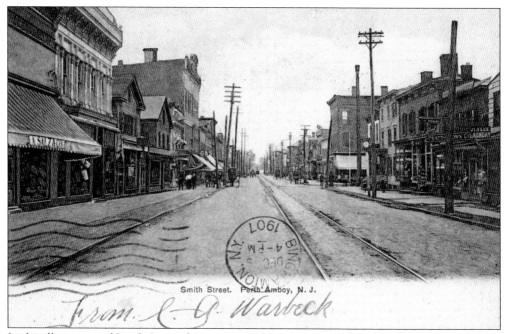

Smith Street. Perth Amboy, N. J.

In this illustration of Smith Street, facing eastward from a point slightly east of State Street, many stores can be seen lining both sides of the unpaved street. Prominent trolley tracks are apparent, undoubtedly getting a lot of use. Terra cotta is noted on several buildings, and the Arthur Kill and Tottenville loom in the distance.

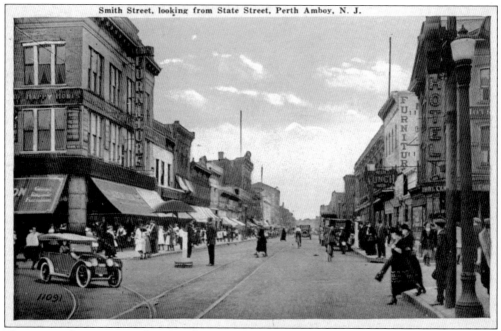

Smith Street, looking from State Street, Perth Amboy, N. J.

This scene, facing eastward on Smith Street from the Five Corners intersection, shows Smith Street bustling with both pedestrian and vehicular traffic. Bicyclists, cars, and pedestrians all seem to have the right of way. Albert Leon's Furniture Store is seen on the northeast corner of the intersection, a hotel on the southeast corner, and many busy stores on both sides of Smith Street.

90

The Kant Building was constructed in 1912 on the northeast corner of Smith and State Streets. Its first tenant was Albert Leon's Furniture, which relocated to the south side of Smith Street after purchasing its own building there. Other tenants followed on the ground floor, and the Penn Loan Company, on the second floor, is remembered for its entertaining animated sign. The building remains a very active retail location today.

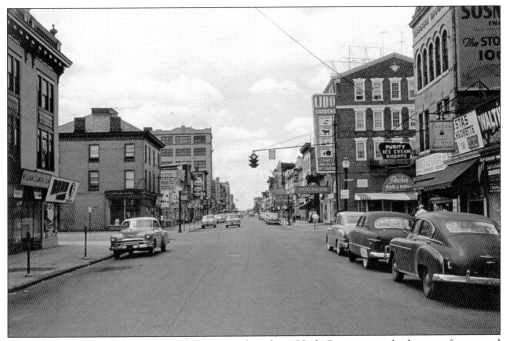

This 1950s westward view of Smith Street, taken from High Street, reveals the storefronts and signs highlighting the many businesses east of the Five Corners. As shown, these include Lido Gardens, Hotel Packer, Strand Theatre, Acme Markets, Ruth's Dress Shop, Crosley, Briegs, Howard, VIM, Crawford, and the multistoried Albert Leon Furniture Store. Parked cars line the paved street, and the traffic light is overhead in the intersection.

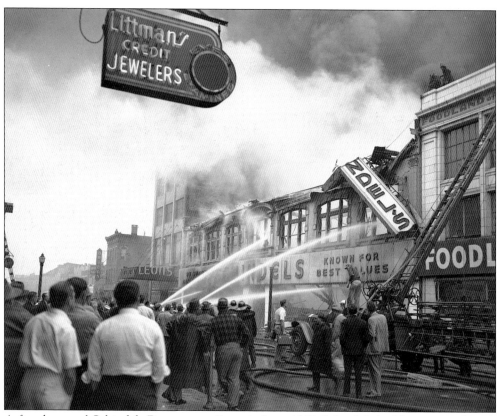

A fire destroyed Schindels Department Store in June 1947. Schindels had been one of Perth Amboy's largest stores, occupying a large portion of the block on the south side of Smith Street between State and King Streets, west of the Albert Leon tower. The structure was originally the 1910 Boynton Building. The store was replaced briefly by Howard, VIM, and Burt's.

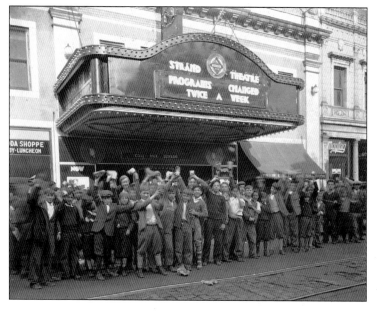

In this 1932 photograph taken during the Great Depression, young boys proudly show their food and drinks while lined up in front of the Strand Theatre, at a time when many were not fortunate enough to have enough food and drinks. They were undoubtedly eager to see *Call Her Savage* with Clara Bow, which preceded the content restrictions imposed by the Hays Code. (GB.)

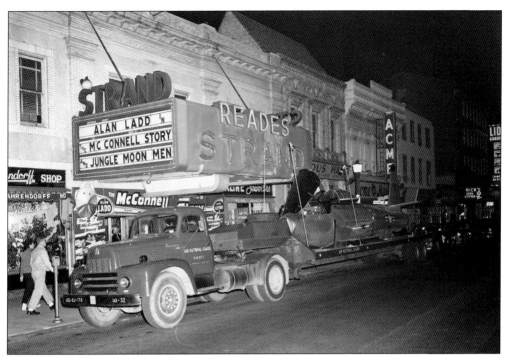

The Strand Theatre was on Smith Street, adjacent to Acme Markets. In 1955, it attracted customers by displaying an Air National Guard F-84 Thunder Jet, which was featured in *The McConnell Story*. This movie was about a Korean War fighter pilot who came home to be a jet test pilot. The second movie, *Jungle Moon Men*, starred Johnny Weissmuller, known for portraying Tarzan.

The Simpson United Methodist Church at High and Jefferson Streets was built in 1866. The church, which is listed in the National Register of Historic Places, is named for Bishop Matthew Simpson, who was a personal friend of Abraham Lincoln. The bishop preached many times at this church, which was the congregation's second building. Their first church building had been located on the southwest corner of High and Commerce Streets.

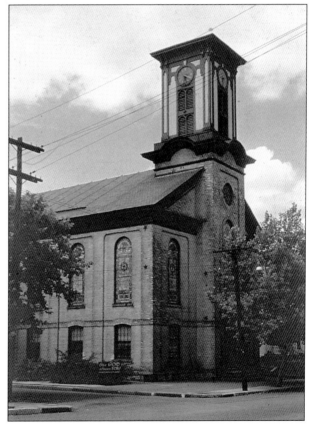

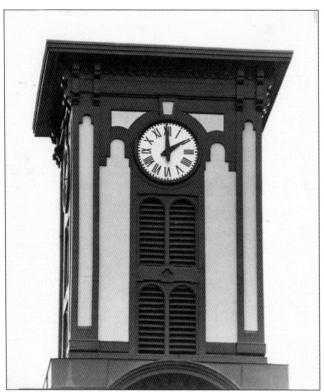

The Simpson United Methodist Church tower underwent several changes after its initial construction, but a central spire was never constructed. In 1866 Perth Amboy paid the church to install the town clock. Facing in the cardinal directions, at 85 feet high, the clock was visible throughout the city. Initially, it was wound manually, but electric motors were installed in 1961. The tower has recently undergone extensive restoration to preserve it.

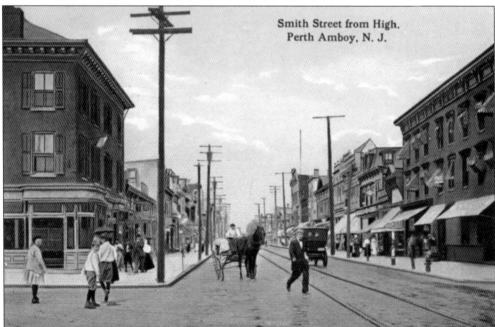

Smith Street from High.
Perth Amboy, N. J.

In this artist's concept of Smith and High Streets, looking west on Smith Street early in the 20th century, the building on the southwestern corner appears to be a saloon with its swinging double doors. On the right, the three-story building on the north side of the street is the Packer Hotel. An early fire hydrant and hitching posts lining the street can also be seen.

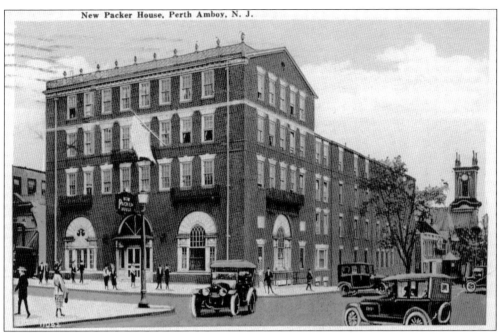

New Packer House, Perth Amboy, N. J.

Built in 1698 and one of the oldest hotels in New Jersey, the Packer Hotel was known as the King's Arms Tavern when George and Martha Washington spent the night of May 22, 1776, there. Later names were Hick's Tavern and Arnold's Hotel before it was renamed the New Packer House in 1874, in honor of Asa Packer, president of the Lehigh Valley Railroad and founder of Lehigh University.

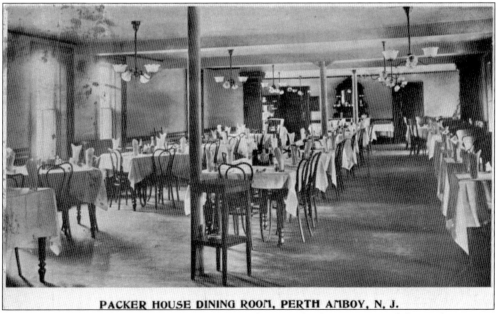

PACKER HOUSE DINING ROOM, PERTH AMBOY, N. J.

The tables are set and ready for consumers in the upscale dining room of the Packer House Dining Room in the early 20th century. This ground-floor restaurant served hotel guests and area residents for many years, and it was replaced by Lido Gardens, a popular restaurant that featured Chinese cuisine.

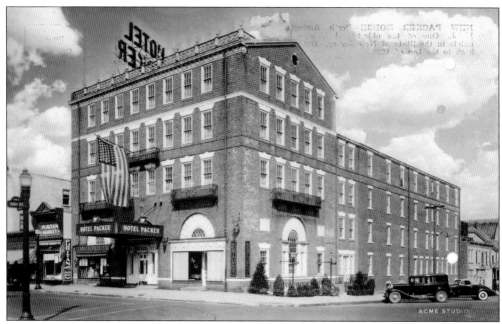

Now named "Hotel Packer" and featuring an added marquee, this was Perth Amboy's largest hotel by the late 20th century. Plaques are seen advertising the hotel's restaurant before the arrival of Lido Gardens. The hotel's 20th-century guests included Pres. Warren G. Harding and Gov. Woodrow Wilson. Unfortunately, the hotel was destroyed by fire in 1969.

Several landmarks are visible in this snow-covered view of High Street, looking north from City Hall Park. On the left are the imposing King High Garage facility and several professional buildings. The Packer Hotel is visible on the corner of High and Smith Streets, and the steeple and clock of the Simpson Methodist Church are one block farther north. Several industries are in the distance, near the Outerbridge Crossing viaduct.

The first location of the Perth Amboy Savings Institution, which had been incorporated in 1869, was at the corner of Smith and Rector Streets. As banking and the city grew, the bank moved to a larger building on the northeast corner of Smith and Maple Streets. The bank went through several ownership changes late in the 20th century and is now recognized as a component of Santander Bank NA.

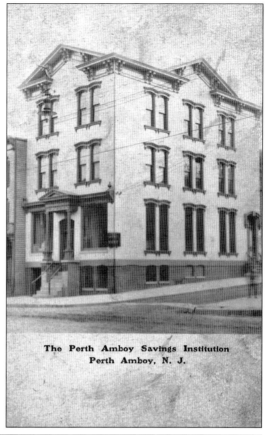

The Perth Amboy Savings Institution
Perth Amboy, N. J.

On the left in this 1956 photograph, facing eastward, north of the ferry slip is the extension of Front Street that ended at Fayette Street. Buildings once located along Front Street included the Ferry Hotel, Perth Amboy Cigar Company, Parker Castle, a repair shop, and a warehouse. The Harbor Terrace Apartments would soon be built in the large vacant area between Rector Street and the Arthur Kill.

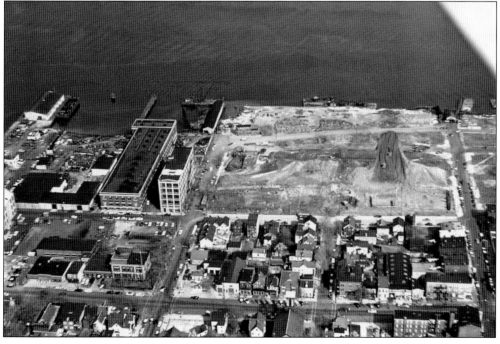

The classic city-style Washington Firehouse, home of the Washington Hose Company, was located near the corner of Smith and Rector Streets. It also served as the meeting place for the Local Home Guard, the special auxiliary police unit established during World War I. The fire tower on the left at the rear was used to hang the canvas fire hoses to dry and prevent rot.

Washington Hose Company. Perth Amboy, N. J.

Parker Castle's stone building was erected north of Smith Street, between Front and Water Streets, in 1702, and the wooden addition dates to 1750. The Parker family arrived in Perth Amboy shortly after the city's founding. As Tories, they supported the British prior to the Revolutionary War. During the war, the British used the building as a barracks and hospital. The building fell into disrepair and was demolished in 1942.

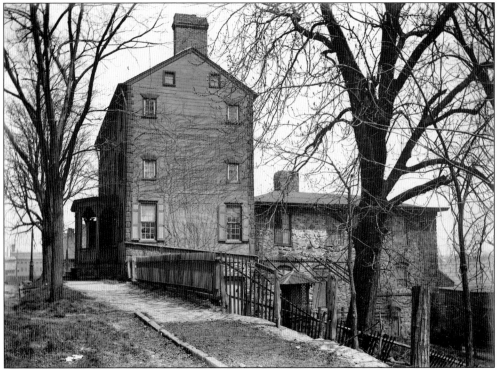

Four

BUSINESSES AND BRIDGES
DUBLIN NEIGHBORHOOD

The Jersey Central Traction Company began service to Perth Amboy in 1911, after Middlesex County built a bridge over the Raritan River, and it connected with Public Service Railways on Smith Street. The streetcar barn serviced Public Service trolleys and, later, the buses that replaced them. This photograph of the west side of the building also shows the still-functional Lehigh Valley Railroad Copper Works spur track that skirted the property.

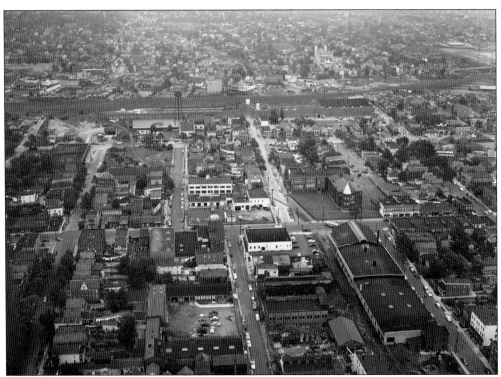

On the north side of Smith Street are No. 4 School (with its white cone-shaped tower), No. 10 School, and Cott Bottling Company. Across Smith Street are the Public Service streetcar barn and Robert Hall Clothes. A water tower can be seen farther north, on Fayette Street. The Lehigh Valley Railroad main tracks are to the left, and the spur winds through the center of the image.

DUBLIN NEIGHBORHOOD

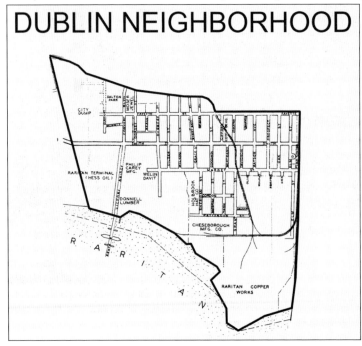

Perth Amboy's Dublin neighborhood occupies the southwestern part of the city. This neighborhood extends from the Lehigh Valley Railroad tracks and Fayette Street on the north to the Raritan River on the south and from Florida Grove Road and City Line on the west to the tracks of the Pennsylvania Railroad and Central Railroad of New Jersey on the east. Landmarks include Raritan Copper Works and Philip Carey Manufacturing.

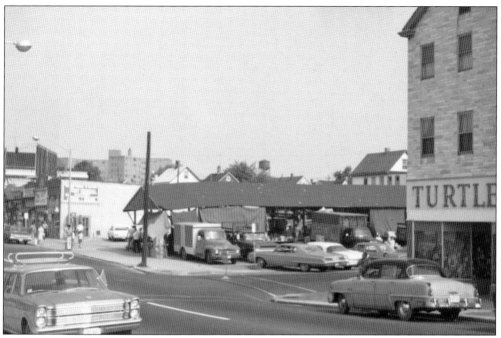

The Farmers' Market, located on Smith Street between Oak and Elm Streets, was in the northeast corner of Dublin, near several bus routes. Local farmers in surrounding communities would bring their produce, eggs, and poultry to sell on market days. With the demise of these farms and the expansion of grocery chains, the market was closed in the 1960s and was replaced by a long-term care facility in the 1970s.

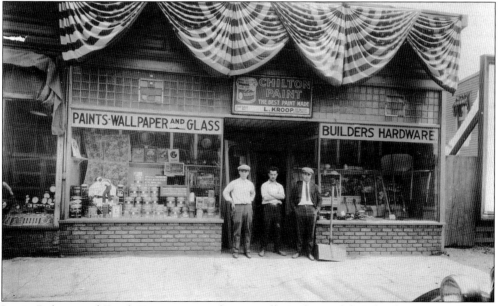

Louis, Robert, and Frank Kroop are standing proudly in front of their hardware store, Dublin Plumbing and Supply, at 332 Smith Street, where they served the neighborhood and many other city residents. The store was slightly east of where No. 4 School stood, and a local restaurant stands at this location today. (Courtesy of Eva Bloom Schlachter.)

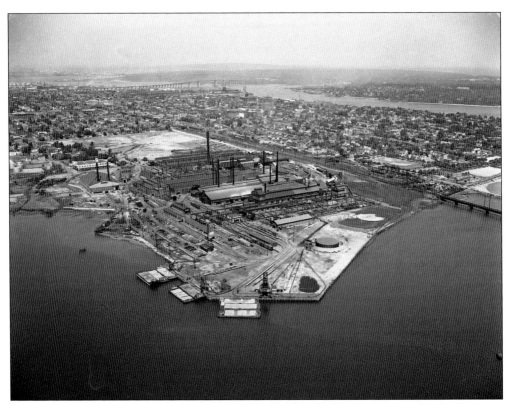

In 1898, Raritan Copper Works selected a deepwater bend in the Raritan River as the ideal location for its refinery. Water access for the heavy shiploads of metal ore improved in 1908 when a larger train bridge replaced the smaller 1895 structure. The plant grew rapidly and later added railroad access to move the finished copper sheets. As copper refining operations grew, gold, silver, and platinum were also recovered.

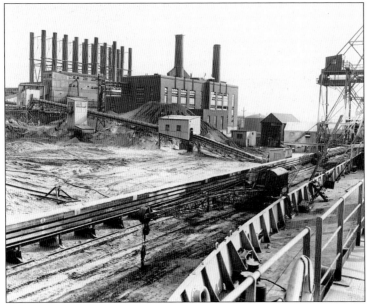

This view of the "Copper Works Internals," as described by local residents, is seen from a docked ship. Heavy lift cranes are to the right, and behind them is a huge pile of coal, required by the ever-hungry furnaces. The long conveyor in the center moved heavy ore and coal into the buildings. This refinery was closed in 1976 when it became uncompetitive.

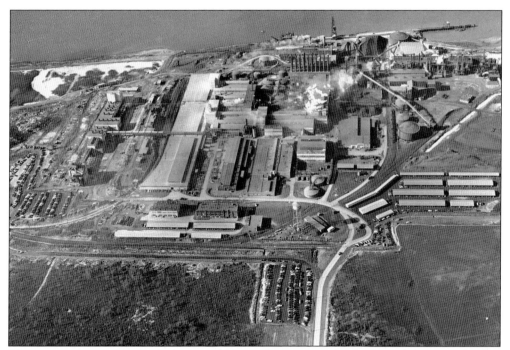

The Raritan Copper Works plant covered 53 acres between Market Street and the Raritan River. This aerial view shows the size of the plant and the 25 miles of narrow-gauge railroad within the plant, needed by the heavy weight of the copper ore, finished sheets, and waste slag requiring transportation. Both the Central Railroad of New Jersey and the Lehigh Valley Railroad had spurs into the plant.

The Anaconda Company, formerly International Smelting and Refining Company, absorbed the Raritan Copper Works Company in 1935. A focus of Anaconda was the electrolytic refining of raw copper anodes into pure copper sheets, a process that consumed large amounts of electrical power. The refinery was sold in 1976, and the site operated as a steel mill briefly.

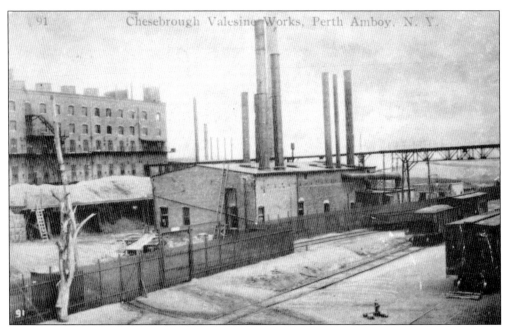

Chesebrough Manufacturing Company, started by American chemist Robert Chesebrough in 1859, was an oil business that produced petroleum jelly (Vaseline). The company's first manufacturing plant for Vaseline, Chesebrough Vaseline Works, was on Patterson Street in Perth Amboy. First patented in the United States in 1872, Vaseline became an international success and remains popular today. The Vaseline factory employed many Perth Amboy residents and continued operations into the mid-20th century.

Trucks advertising and carrying various Vaseline products were commonly seen in the Dublin neighborhood, where the factory produced them. In addition to the common petroleum jelly that remains available today, many related products, such as the Vaseline Cream Hair Tonic seen on this truck, were also produced. In 1955, Chesebrough Manufacturing merged with Pond's Extract Company to become Chesebrough-Pond's USA.

The trolley car barn on Smith Street between Bertrand Avenue and Davidson Street was built by Public Service in 1915, four years after the Jersey Central Traction Company connected its tracks with the Public Service Smith Street line at this location. The building housed Public Service trolleys and, later, buses. When Bertrand Avenue was repaved in 2016, streetcar rails were uncovered and donated to the Liberty Historic Railway organization.

The Public Service car barn survived the end of servicing buses and became the home to Royal Dinette Company, a business that sells and repairs furniture. Many of the building's original features were lost during this period, but many of the historic features were retained or returned after it was acquired by the American Industrial Supply company. This photograph shows the building after some renovations.

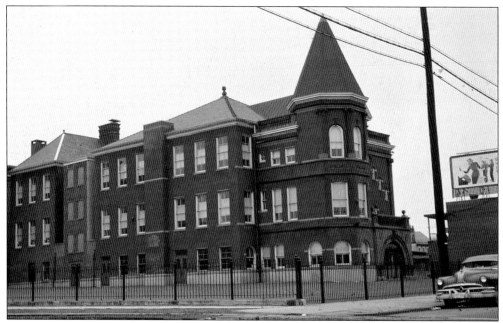

No. 4 School was built in 1896 on Smith Street across from the streetcar junction to serve the rapidly growing population in this area. The school expanded several times and soon became the largest building in the city. However, even more elementary school classrooms were needed, and No. 10 School was built adjacent to No. 4 School in 1915.

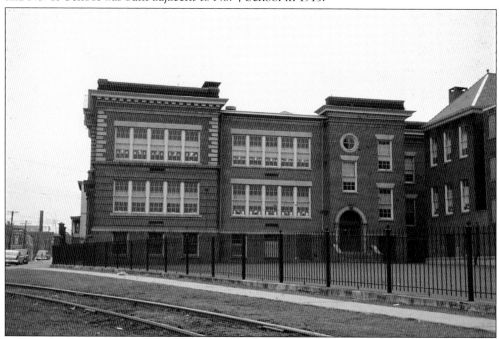

Pictured in 1953, Nos. 4 and 10 Schools stood side by side on the northeast corner of Smith and Stockton Streets, where they were the elementary schools for all children in this neighborhood. The Dublin neighborhood is now served by the Dr. Herbert N. Richardson 21st Century Elementary School at this location.

Halloween was celebrated at all of Perth Amboy's public elementary schools, giving all students a chance to display their costumes and celebrate the holiday. Seen in the background, across Smith Street, is Robert Hall Clothes, a large national retailer where many families shopped. Also visible are the Marathon Bus Company's Keansburg bus and the Lehigh Valley Railroad track behind the fence.

Community members and school administrators pose for this Christmas photograph in 1953. Seated, left to right, are Anthony V. Ceres (superintendent of schools), Mary E. Stack (assistant principal of Nos. 4 and 10 Schools), and Marguerite Boughton (principal of No. 4 School). Stack and Boughton were the administrators of Nos. 4 and 10 Schools at a time when men held most of the school system's administrative positions.

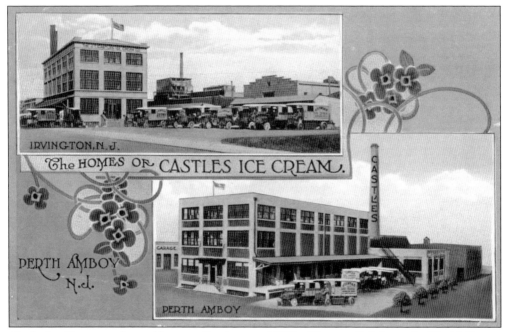

IRVINGTON, N.J.

The HOMES OF CASTLES ICE CREAM.

PERTH AMBOY N.J.

PERTH AMBOY

Castles Ice Cream was located between Stockton and Gifford Streets, slightly north of Smith Street. This building later became home to the Cott Bottling Company. The property is currently Our Lady of Fatima Church, which relocated to this site when its previous home, between Lawrence and Grove Streets in the Northern neighborhood, was demolished by the construction of Route 440.

Located on Kirkland Place, near Fayette Street, the Magyar Reformed Church was organized in 1903 by the Hungarian community living nearby. The current brick church was built in 1925. While some services are in Hungarian, all cultural and religious backgrounds are welcome at the church. This neighborhood remains quiet, in contrast to the industrial nature of Fayette Street, where Puritan Dairy and Flagstaff Foods once operated.

Looking west from Goodwin Street in the early 1960s, Smith Street has an energetic mix of retail businesses of all kinds, including bakeries, tire stores, bars, car dealers, food stores, and gas stations. These served the nearby residents, as well as shoppers from other communities. Goodwin Street is now a primary access point to Perth Amboy from the Route 440 connector.

Located on the corner of Smith and Grace Streets, Dublin Radio was a specialty store that existed before the advent of big-box stores and discount highway merchants. The store sold and repaired radios, televisions, record players, and other electronic equipment and also sold supplies for home repair enthusiasts. Yanek's Bar and Grill, which featured a television, can be seen next to the Banas Oil Company offices on Grace Street.

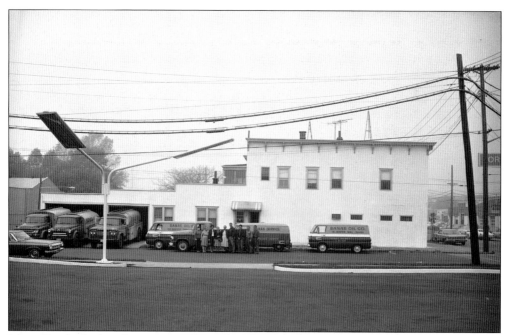

Many Perth Amboy homes were heated with coal, despite the storage and maintenance inconveniences and the health hazards. Eventually, city residents switched to oil as a more desirable alternative, since it could be stored in underground or basement tanks. The Banas Oil Company understood the opportunity to serve this new demand, and their trucks became a familiar sight in the city.

At least two sections of Perth Amboy had city recreation centers called "The Rec" by residents. This one was located on the corner of Smith and Goodwin Streets. Children enjoyed being able to play games and ping-pong at the center. Activities regularly included talent shows and ping-pong tournaments, and everyone looked forward to the trophies and awards.

Entertainment in the Dublin neighborhood in the 1950s included the carnival at Pardee's Field, located at the western end of Market Street. To announce its arrival and to attract visitors, the carnival used sky-piercing searchlights that were visible from surrounding communities. Carnivals took place in multiple locations throughout the city.

Pardee's Field was also used for baseball games between industry teams. Located at the western end of Market Street, it was surrounded by several industries, including Pardee Tile Company and the Welin Davit and Boat Corporation. Some of the Welin Davit and Boat Corporation's boats are seen in the background. This area was also the home of the Eagleswood Military Academy.

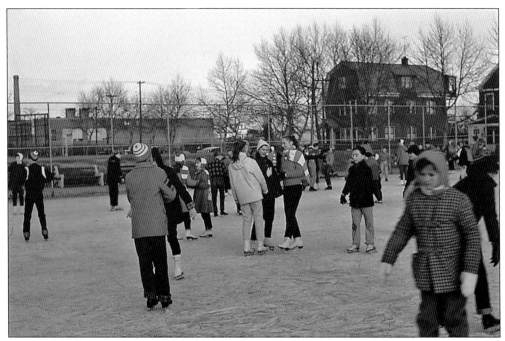

The crowd is having fun ice skating at the Dorsey Street tennis courts, approximately 1950, following Perth Amboy's long-standing winter tradition of flooding and freezing its tennis courts for this purpose. At the peak of ice skating popularity, the city also tried flooding and freezing basketball courts in areas that were lacking tennis courts. Milder winters in recent years have led to year-round basketball in all city parks.

Following a long-standing tradition, graduating seniors in the Perth Amboy High School class of 1965 are signing each other's yearbooks with messages of good wishes. This yearbook signing party took place at the well-known Bel Air Inn on Fayette Street. Graduates usually continued socializing at summer baseball games, congregating at the Stand on Sadowski Parkway, and cruising down Smith Street on Saturday nights.

Proud owners of D. Kaden Trucking Company, father and son David and Reuben Kaden are posing with some of their drivers and mechanics in front of company trucks at Flagstaff Foods warehouse on outer Fayette Street. Flagstaff Foods was a major wholesale grocery business in Perth Amboy, and D. Kaden Trucking Company was a contract carrier for Flagstaff Foods. (Courtesy of Daniel Kaden.)

The Lehigh Valley Railroad's line into Perth Amboy expanded to four tracks through the center of town to accommodate large coal trains heading to the piers along the Arthur Kill. Between Florida Grove Road and Convery Boulevard, the branch track pictured in this December 1947 snowstorm split off and threaded its way across Fayette and Smith Streets to the Raritan Copper Works, where it delivered coal.

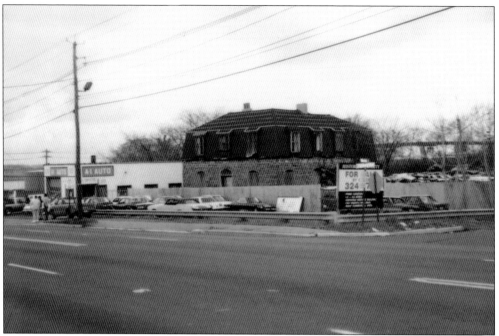

George Inness (1825–1894) was an American landscape painter and was often referred to as "the father of American landscape painting." His home, seen above near the corner of Convery Boulevard and Smith Street, was part of the Eagleswood community of the 1860s and was the artist's residence and studio from 1865 to 1868. The George Inness House was built for him by Marcus Spring, the founder of the Eagleswood Community. *Peace and Plenty*, a work now in the Metropolitan Museum of Art, was created by Inness as repayment to Spring. The snow-covered house seen in the 1947 photograph below ended up as a repair shop and used-car business from the 1940s to the 1980s. It was quietly demolished in 1993.

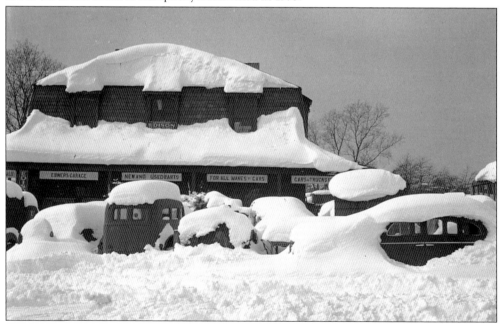

The Hess Oil Company constructed a wharf and small oil terminal on the upstream side of the Victory Bridge and built several large oil-storage tanks next to the unloading area. Oil barges moving through the Victory Bridge frequently caused delays that frustrated factory workers and commuters in the 1960s and 1970s. The site was recently acquired by the Buckeye Oil Company and connected by pipeline to the former Chevron refinery.

The Donnell Lumber Company, one of Perth Amboy's largest lumber suppliers, was a familiar sight to travelers using the Victory Bridge, since it was directly east of the bridge. The New Jersey Highway Department built the Victory Bridge on the lumber company's property. As seen in this 1966 photograph, the lumber yard was substantially destroyed by a fire, and the company's safes were the only surviving items.

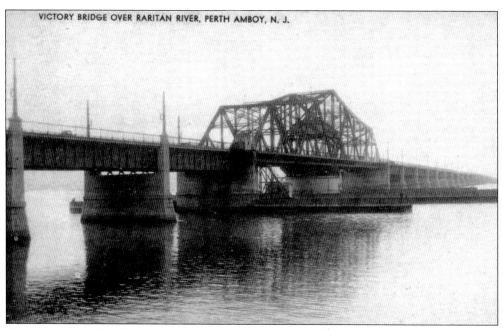

The Victory Bridge was a historic Perth Amboy landmark that was completed in 1926. Although it was demolished in 2005, it remains recognized as the largest swing span vehicular bridge built in New Jersey, with a swing span of 365 feet. Many longtime Perth Amboy motorists remember how hot summer weather occasionally caused the bridge to "get stuck" in the open position, causing traffic backups as far as Smith Street.

With a huge celebration, the Victory Bridge was opened in 1926 and dedicated to American World War I troops. The bridge served as a critical link in New Jersey's highway system, since it was the only Raritan River crossing east of New Brunswick until the Edison Bridge was opened in 1939. The bridge was replaced by a fixed-span bridge in 2005.

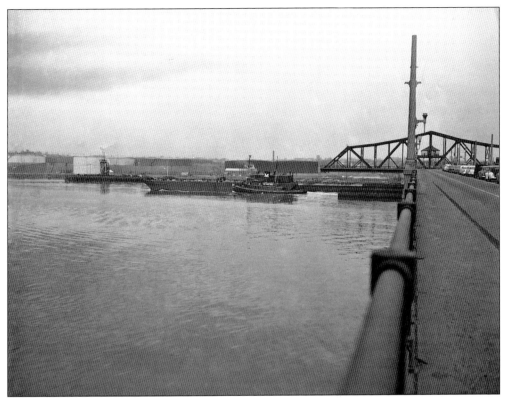

In this photograph, a tugboat can be seen pushing an oil barge through the open Victory Bridge to the Hess terminal, causing the usual traffic jam. The large, 365-foot center span of the Victory Bridge pivots around a center pedestal, leading to the term "swing bridge" and creating two ship channels, each 25 feet deep and wider than the original Panama Canal.

As crew members watch from the ship's deck, two tugboats delicately push two bulk cargo barges through the ice-filled Raritan River, passing under the open Victory Bridge. The tall smokestack on the lead tug, the St. Lawrence, and the cargo booms on the barges require the swing span to be open. Proudly displayed on the ship's stack is "Amboy." (PB.)

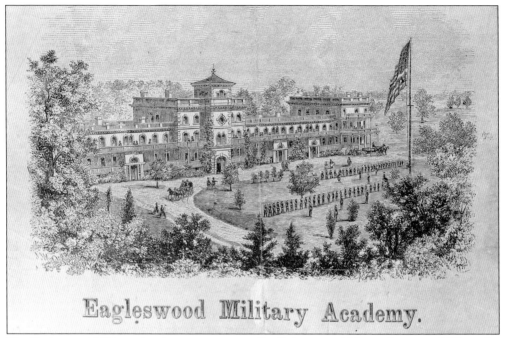

Eagleswood Military Academy.

The Eagleswood Military Academy was organized by Rebecca and Marcus Spring in 1861 on the site of the Raritan Bay Union, south of the western end of Market Street. After the academy closed, the building became the Eaglewood Park Hotel until it was purchased in 1888 by Calvin Pardee, who built a ceramic tile company there. The rest of the Eagleswood Military Academy was demolished in 1933. (GB.)

This 1950s aerial view of western Dublin shows the neighborhood's remarkable mix of industry, homes, businesses, and recreation. The Philip Carey Manufacturing Company dominates the center of the photograph, and rows of lifeboats are seen at the Welin Davit and Boat Corporation. Also visible are two remaining structures of the Eagleswood community, the Parkhurst House and the Inness House, as well as the city incinerator's smokestack and Dalton Field.

Five

Churches
and Railroads
Central Neighborhood

Located on New Brunswick Avenue between Groom Street and Convery Boulevard, Perth Amboy General Hospital opened in 1902 and has served Perth Amboy and surrounding towns since then. The hospital has undergone expansions, renovations, name changes, and mergers, and it is currently Hackensack Meridian Raritan Bay Medical Center. This photograph shows the hospital shortly before it became Raritan Bay Medical Center.

This aerial view, facing northeast, shows most of Perth Amboy's Central neighborhood in the foreground and much of the Northern neighborhood in the background. Several prominent landmarks can be seen in this view, including Perth Amboy General Hospital and its parking lot on New Brunswick Avenue, No. 8 School on Convery Boulevard, Shull School on Hall Avenue, and the cigar factory on Johnstone Street.

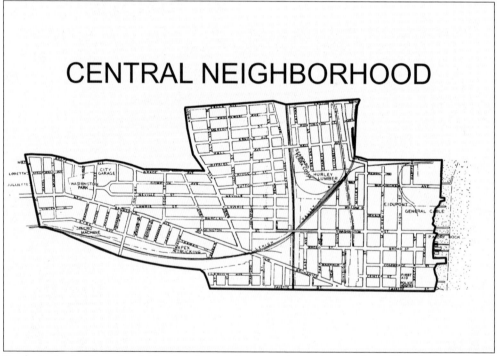

Perth Amboy's Central neighborhood extends across the entire city from Florida Grove Road on the west to the Arthur Kill on the east. The Central neighborhood extends northward from the Lehigh Valley Railroad tracks and Fayette Street to Brace Avenue, Eagle Avenue, Wayne Street, and the Lehigh Valley Railroad tracks. Landmarks include General Cable, Perth Amboy Dry Docks, and Washington Park.

Located on Cortlandt Street, Our Lady of Hungary Roman Catholic Church has served Perth Amboy's large Hungarian community since it was established in 1902. After the first church burned, the current church was built on the same property in 1911. It is currently part of the Most Holy Name of Jesus Parish.

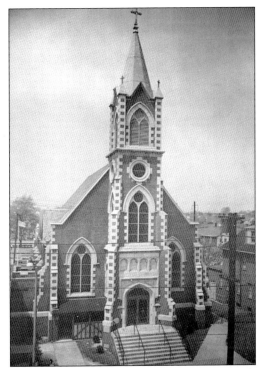

The elegant interior of Our Lady of Hungary Church can be seen as the congregation celebrates the crowning of Mary. This Roman Catholic tradition honors Mary during the month of May with prayers and by placing a crown of flowers on her statue. This celebration at Our Lady of Hungary Church on Cortlandt Street is one of many similar events that took place at other Catholic churches in Perth Amboy.

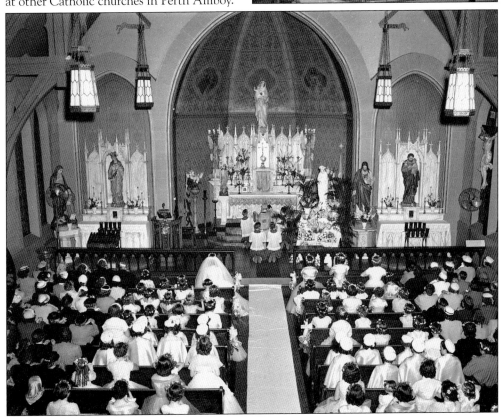

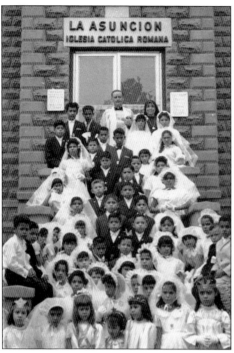

As the Spanish-speaking population of Perth Amboy grew, so did the need for Spanish-speaking places of worship. La Asuncion Church, shown here when it was on Wayne Street, was one of the first Catholic parishes to address the needs of Spanish-speaking immigrants. Today, La Asuncion Church meets in the Catherine Street building that was formerly Our Lady of Hungary School and property.

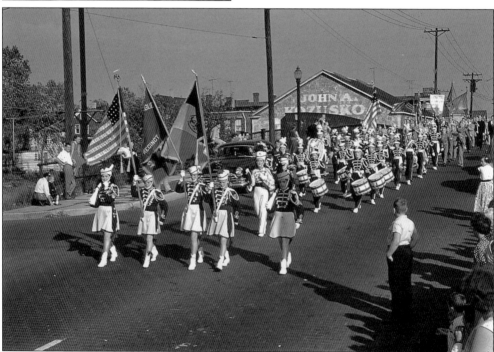

In this 1956 photograph, a Perth Amboy holiday parade can be seen crossing the Hall Avenue overpass over the main tracks of the Pennsylvania Railroad/Central Railroad of New Jersey. This overpass was one of five that were constructed after the tragic fire-truck accident at the grade crossing on Market Street, and it linked the developing northwestern part of the city with the thriving business community on Hall Avenue.

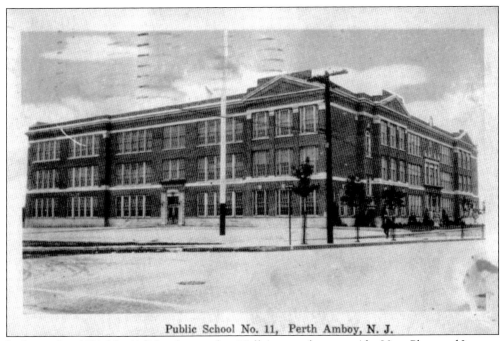

Public School No. 11, Perth Amboy, N. J.

In September 1924, No. 11 School opened on Hall Avenue, between Alta Vista Place and Jacques Street, to provide kindergarten through eighth-grade education in the northern parts of the city. It was renamed the Samuel E. Shull School in 1932 in honor of Samuel E. Shull, who had served as superintendent of Perth Amboy's schools from 1895 to 1930. The school is now a middle school, serving grades five through eight.

The only branch of the Perth Amboy Free Public Library was located in the basement of Shull School, adjacent to the boys' playground. The branch was intended to serve the large number of children who lived in the northern part of the city within walking distance of Shull School. Although the library's name remains inscribed in the stone, the space has been converted into art rooms.

Perth Amboy has many Catholic churches which represent different religious and ethnic backgrounds. St. Michael's Church is a Byzantine Eastern Catholic Church of the Hungarian tradition. Located on the southeast corner of Hall Avenue and Amboy Avenue, it is situated at the highest point of the hill. At this location, this church has been serving the community since 1914.

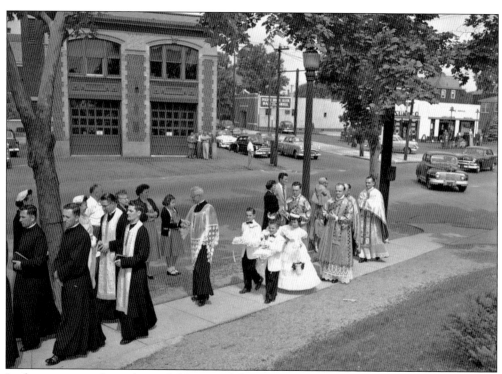

In the procession shown here, children are following the clergymen into St. Michael's Catholic Church, at the intersection of Amboy and Hall Avenues. Across the street, in the background, is the Garfield Engine Company No. 5 Firehouse. This unique building is no longer a firehouse, but it has been preserved and is now home to the Ukrainian National Credit Union.

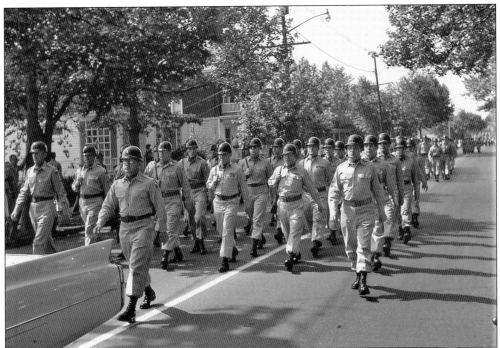

The annual Memorial Day Parade was a regular tradition in Perth Amboy, honoring those who died in the service of our country. It was customary to include several military contingents as participants in the ceremonies, as shown here. The parade route passed the Alpine Cemetery before ending at Waters Stadium for the ceremonies that followed.

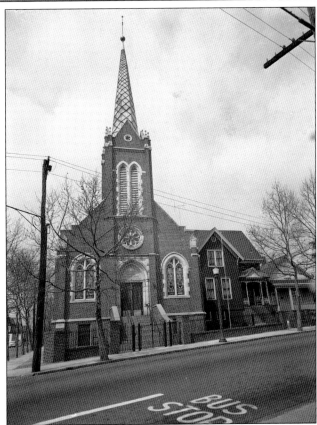

Formed as a Hungarian Church in 1929 by members of the Magyar Reformed Church on Kirkland Place, the John Calvin Church was located at the corner of Amboy Avenue and Neville Street. As the city grew, this long and uphill section of Amboy Avenue became known as the "Amboy Avenue Business District," which offered neighborhood residents a convenient shopping alternative to the long trip to the Smith Street businesses.

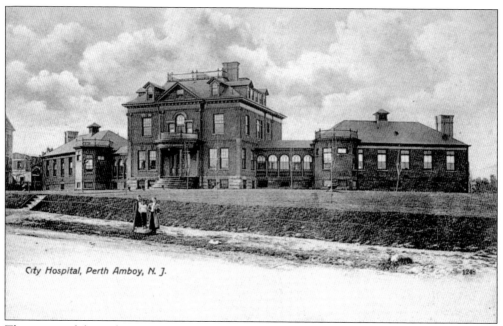

City Hospital, Perth Amboy, N. J.

This is one of the earliest images of Perth Amboy General Hospital, which opened in 1902. Its location on New Brunswick Avenue was in a rural and largely undeveloped part of the city with unpaved roads. As the population in the hospital neighborhood grew, the town aldermen voted in June 1914 to pave New Brunswick Avenue, sparking additional growth in this neighborhood.

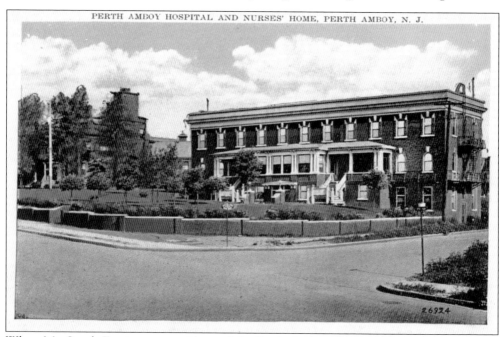

PERTH AMBOY HOSPITAL AND NURSES' HOME, PERTH AMBOY, N. J.

When Mr. South Farrington, president of the Perth Amboy General Hospital Association, resigned in 1914, he was praised by the board for his work and accomplishments, which included expanding the hospital and adding a home for nurses. Later, in 1924, a nursing school was added to meet the demands of the hospital for additional staff.

126

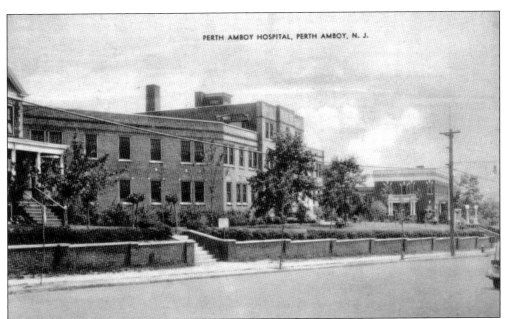

PERTH AMBOY HOSPITAL, PERTH AMBOY, N. J.

By 1920, the population of Perth Amboy had grown to almost 30,000 people, creating a need for additional expansion of the hospital. This photograph shows the new wing extending to the nurses' residence. Perth Amboy General Hospital continued to grow and provide medical care for the city's residents. The hospital now occupies the entire city block bounded by New Brunswick Avenue, Groom Street, Lawrie Street, and Convery Boulevard.

Dr. Harry Martin Brace served the citizens of Perth Amboy at the beginning of the 20th century as both mayor and physician. He was a childhood friend of Pres. Theodore Roosevelt and arranged a presidential visit to Perth Amboy in 1905 during his term as mayor. Brace Avenue was named in his honor, shortly before his untimely death in 1906.

Dr H. Martyn Brace,

127

Once part of the Compton farm, the land in this photograph was the home of the city Alms House, the isolation ward of the hospital, and later Washington Park. Seen on the right is the Middlesex County Vocational School, which opened on New Brunswick Avenue in 1916, replacing the county vocational school on Bertrand Avenue. (PAFPL.)

To meet the growing population's need for more recreational space, Washington Park was created at New Brunswick Avenue and the future Lee Street. The grandstand on the left predates the completion of the park. Dormitories are in the distant center. The newly constructed vocational school is on the right. The city water standpipe on Brace and Lee Streets appears behind the new city garages. (PAFPL.)

128

By the early 1960s, the wooden grandstands at the Washington Park baseball field were gone, and all that remained were the third base dugout and the water fountain. The water fountain became a welcome gathering place for both players and spectators. Children were always pleased to find that they could get a drink without dismounting from their bicycles. (PAFPL.)

Today, Washington Park is even more attractive, following the removal of the swimming pool, the addition of a children's playground, new landscaping, and revision of the ball field. The tennis courts were converted to basketball courts that were dedicated to Brian Taylor in August 2021. As shown here, the new arch over the New Brunswick Avenue entrance topped it all off and provided the shortest route to McDonald's.

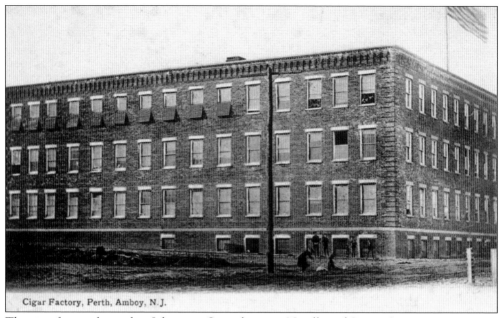

Cigar Factory, Perth, Amboy, N.J.

The cigar factory, located on Johnstone Street between Neville and Sutton Streets, was imposing to residents in both sight and aroma. It was a neighborhood employer for a large number of workers who lived within walking distance. When cigar production ended for this landmark, the building housed the State Insulation Company and now includes several small businesses.

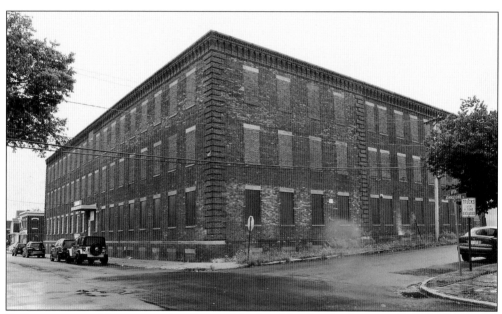

Still in its original location and still a neighborhood landmark, the cigar factory building on Johnstone Street looks substantially the same today as it did a half-century ago. The businesses inside the building have changed, but the doors, windows, entrances, and other external features of the building remain unaltered.

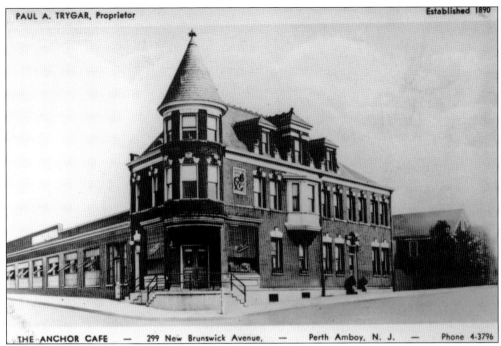

The Anchor Café, with its decorative roofline, was a landmark since 1890. Located on the corner of New Brunswick Avenue and Prospect Street, it was across New Brunswick Avenue from the Lehigh Valley Railroad freight station and the future Carvel stand, which was later built one block away. The large second floor was frequently used for banquets and even wedding receptions. The building is still used by small businesses today.

The popularity of soft ice cream in the early 1950s was typified by the classic appearance of the Carvel ice cream stand at the intersection of New Brunswick Avenue and Oak Street. One of the first in the area, the Carvel stand has had several owners and attractive upgrades and remains a neighborhood landmark.

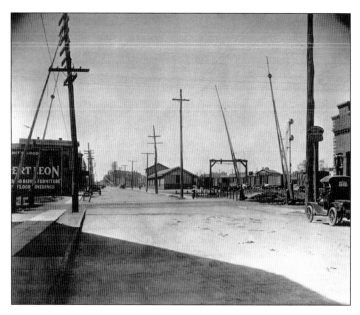

This street-level grade crossing of the Central Railroad on Washington Street predates the grade crossing collision of a fire truck and train, several blocks away on Market Street, that resulted in several deaths. A steep bridge was later constructed on Washington Street, above both the Lehigh Valley & Pennsylvania Railroad tracks. A portion of the Lehigh Valley Freight Station on New Brunswick Avenue is visible on the right. (PAFPL.)

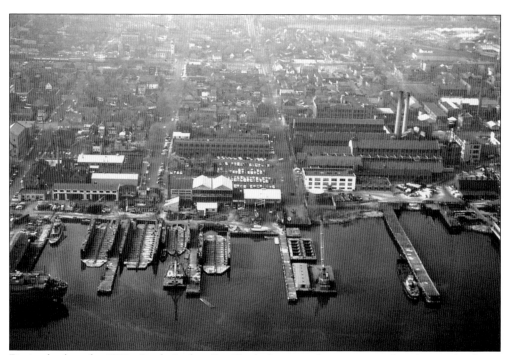

Dating back to the 1880s, Perth Amboy Dry Dock slips served many types of civilian and military marine vessels, including sailing ships, tugboats, tankers, cargo ships, ferries, and military and supply ships. The four docks in this aerial view at the end of Washington Street had a 2,500-ton lifting and securing capacity and also provided ancillary support services. The USS *Holland* (SS-1), the first submarine built, was berthed here.

John Hammond, an Irish American school teacher and inventor, was a pioneer in developing the submarine. When the Holland submarine sank while at Elizabethport because of an open valve, John Hammond recovered the vessel, restored its electric motor, and moved the vessel to the dry docks in Perth Amboy, as pictured here in 1898. The submarine made many trial runs in the waters surrounding Perth Amboy.

Sitting on the keel blocks in one of Perth Amboy's dry docks with a clean hull and single propeller, this steamship appears to have been repaired and is now ready to be launched back into the harbor. When the berth is flooded, the ship will float up and off the blocks. Perth Amboy's dry docks were able to accommodate most of the deep-draft vessels working in New York harbor. (PB.)

The Lehigh Valley Freight Station is located on the north side of New Brunswick Avenue, east of the Lehigh Valley Railroad tracks, with Oak and Prospect Street corners to the south. The freight station was reached by a branch from the multitrack section of the railroad that served as the staging area for arriving coal trains. The passenger station was near the corner of Amboy Avenue. (GB.)

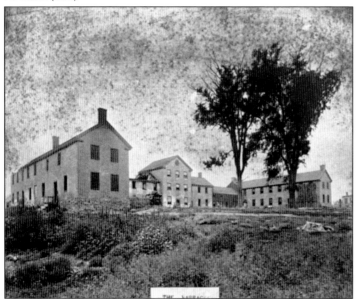

Built in 1758 by the British Army to accommodate their soldiers during the French and Indian War, these buildings ("the Barracks") were first occupied by troops returning from the capture of Havana in 1762. In subsequent years, the Barracks were occupied by British troops until their evacuation from New Jersey. The Grammar School was later built on this site on Barracks Street.

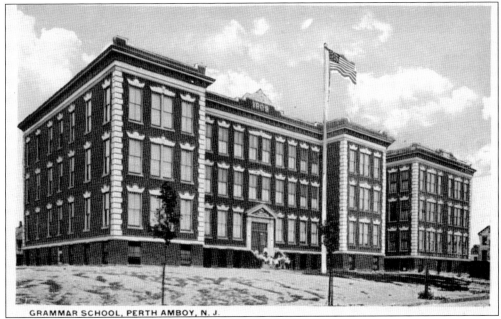

GRAMMAR SCHOOL, PERTH AMBOY, N. J.

First proposed in 1908 to accommodate the increasing overcrowding in Perth Amboy's public schools as the city's population grew rapidly, the Grammar School was built in 1909 on the site of the Barracks. It consisted of 18 classrooms, a sewing room, and a room for the teachers. The portable building used at No. 4 School was moved to the Grammar School to serve as a manual training shop.

From 1909 until 1972, middle-grade students living in the southern section of Perth Amboy attended Grammar School, while northern residents attended Shull School on Hall Avenue. In 1972, Perth Amboy opened its new high school on Eagle Avenue and converted the former high school on State Street to a middle school. Currently, the original Grammar School building houses the Perth Amboy Board of Education and district administrative offices.

SAINT STEPHENS POLISH CHURCH, PERTH AMBOY, N. J.

The towering St. Stephen's Church is located on State Street at the corner of Buckingham Avenue. This Roman Catholic church has served Perth Amboy's Polish Catholic community since 1892. The present neo-Gothic structure, shown here, replaced a smaller facility at the same location in 1919. The school associated with St. Stephen's Church is now the Perth Amboy Catholic School.

Mayor George Otlowski accepts a statue of the great Polish astronomer Nicolaus Copernicus from the United Poles of America in a 1973 ceremony at St. Stephens Church, commemorating the 500th anniversary of his birth. The sculpture, made by Florian Rachelski and cataloged by the Smithsonian Institution, has been relocated to the International Park section of Caledonia and Roessler Park at the corner of High Street and Sadowski Parkway.

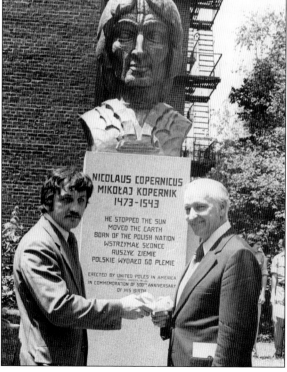

Perth Amboy held many parades throughout the year to celebrate holidays and other occasions. Participants often included local Girl Scout and Boy Scout troops and school marching bands. In this parade, heading north on State Street, Girl Scouts can be seen marching with their leader. The influence of the city's newest immigrants can be seen in the renaming of older, established stores.

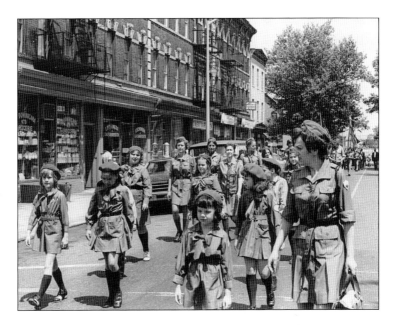

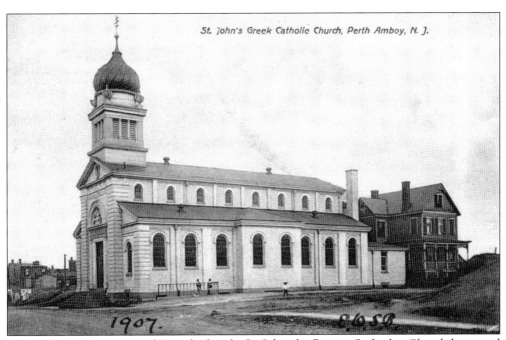

Founded in 1897 in a rented Danish church, St. John the Baptist Orthodox Church has stood on the corner of Broad and Division since 1904. This picture shows the church before a second steeple was added in 1913. Following continued growth, the church became one of the largest Greek Catholic parishes in the country and is now one of the oldest parishes in the American Carpatho-Russian Orthodox Diocese.

St. Mary's is the oldest Catholic parish in Perth Amboy, dating back to the mid-19th century. Established for the growing Irish Catholic community, St. Mary's Church was dedicated in 1905 and is located on Center Street at the corner of Mechanic Street. This postcard shows the striking interior of the neo-Gothic church and its vaulted ceilings. The parish community also included a convent and primary and secondary schools.

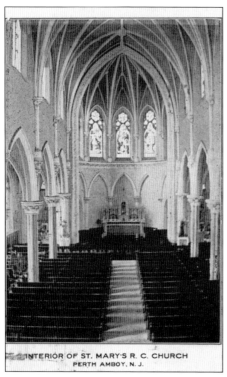

INTERIOR OF ST. MARY'S R. C. CHURCH
PERTH AMBOY, N. J.

As seen here in one of Perth Amboy's traditional holiday parades, this marching band is crossing Broad Street as it heads north on State Street. A Perth Amboy landmark store, Jag's Sporting Goods, is in the background. This store outfitted many locals teams and athletes. The owner, Henry Jaglowski, was also a member of the Perth Amboy Board of Education.

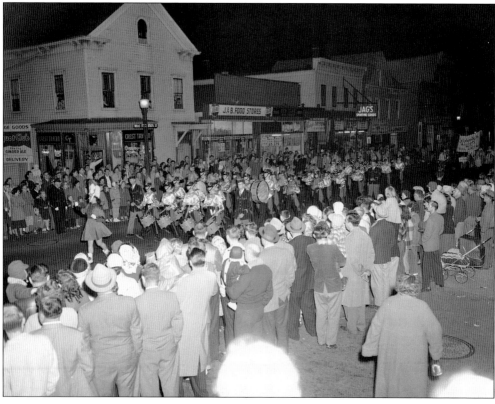

Six

GREEN SPOTS
AMID INDUSTRY
NORTHERN NEIGHBORHOODS

During the expansion of the Perth Amboy refinery, California Oil's catalytic cracking unit was the centerpiece of the plant. Known locally as the "Cat Cracker," it produced gasoline, kerosene, heating oil, and other fuels. A Perth Amboy landmark, it was visible throughout the region. Secondary refining units are at the smokestack to the left. A temporary tunnel under the Pennsylvania Railroad for construction workers is visible below the cracker.

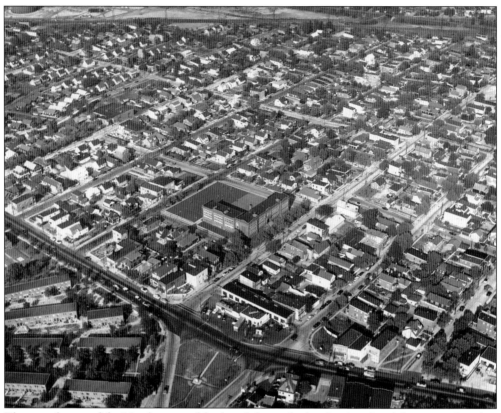

This aerial view of the Northern neighborhood shows the key landmarks of the area referred to as Budapest. These include No. 9 School, the New Jersey Motor Vehicle Inspection Station, the William A. Dunlap Homes, the Ace Sign Shop, and Francis Street Park. The large playground stands out at the school. Route 440 now divides the area where Grove and Lawrence Streets once handled the bridge traffic.

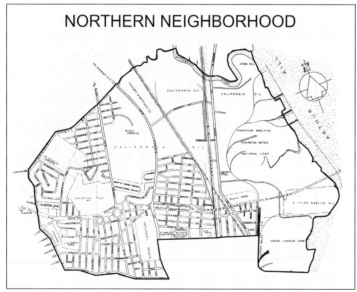

The Northern neighborhood occupies the entire northern part of the city, extending from Florida Grove Road on the west to the Arthur Kill on the east and from Woodbridge Creek on the north to Brace Avenue, Eagle Avenue, Wayne Street, and the Lehigh Valley Railroad tracks on the south. Landmarks include California Oil, National Lead, Alpine Cemetery, and Waters Stadium.

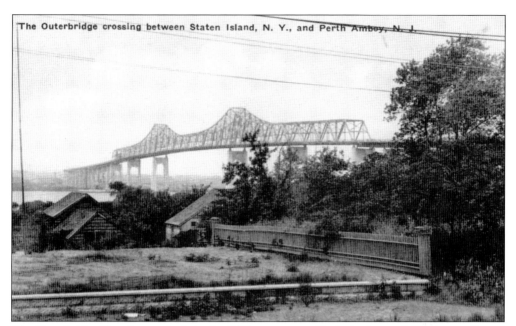

The Outerbridge Crossing was built in the 1920s to connect Perth Amboy and Charleston, Staten Island. The Port Authority of New York opened the bridge on June 29, 1926, to accommodate interstate traffic. Designed by John Alexander Low Waddell, the bridge was named in honor of Eugenius H. Outerbridge, who was an early chair of the Port Authority of New York.

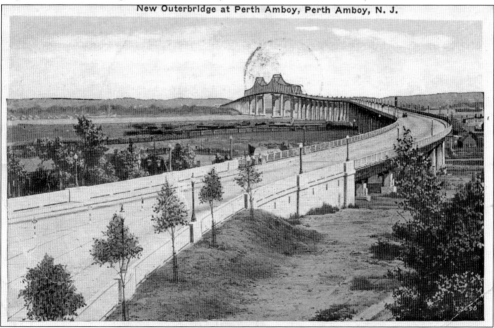

New Outerbridge at Perth Amboy, Perth Amboy, N. J.

This prescient postcard image depicts the Outerbridge Crossing and approach many years after opening, reflecting changes in response to the needs of the Port Authority and the increased traffic between New Jersey and New York. The Eisenhower Interstate Highway System and its interchanges put additional traffic on the bridge and approach, with major changes occurring on the Perth Amboy side in the late 1960s and early 1970s.

Viewed today from the same location as the previous image, the surprising growth in size and complexity of the Route 440 highway system that feeds onto the Outerbridge Crossing is apparent here. Construction of Route 440 between 1967 and 1972 cut a devastating path through the Northern neighborhood, with many people losing their homes and businesses and being forced to relocate.

Looking west on a cold March afternoon, the sun angle produced sharp contrasting shadows under the Outerbridge Crossing viaduct at Rudyk Park. The cathedral-like appearance of the area was complemented by the echoes of children playing and batting baseballs in the park. The long viaduct connects Route 440 from the high area of Perth Amboy, near Francis Street, to the cantilever section that spans the Arthur Kill.

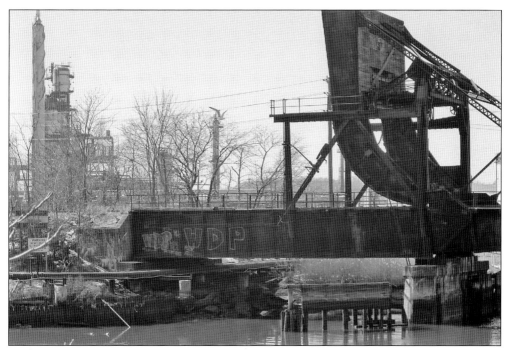

As the Central Railroad of New Jersey tracks run parallel to and slightly west of outer State Street, the train line's bascule bridge crosses Woodbridge Creek. The former "speedway" for commuter trains to Jersey City is now an active freight line serving Buckeye Oil. The rusting structure, which no longer opens, sits on the northeast border of Perth Amboy. The Chevron Asphalt Plant is seen in the background.

The box-like main building of the National Lead Company on Outer State Street was located between the ASARCO Refinery and the Abarry Steel Company. After National Lead acquired Dutch Boy Paints for the production of lead-based paints, the top of the building featured both the National Lead sign and an illuminated Dutch Boy Paints sign, which were visible from the Budapest neighborhood and the Outerbridge Crossing.

All the large industries communicated regularly with their employees, providing them with both business and social information. The National Lead Company's professional newsletter, the *Melting Pot*, was published monthly. In addition to factory news, the November 1952 issue highlighted the employees' need and responsibility to vote in the presidential election. It also included an appeal for charitable contributions to the local Community Chest.

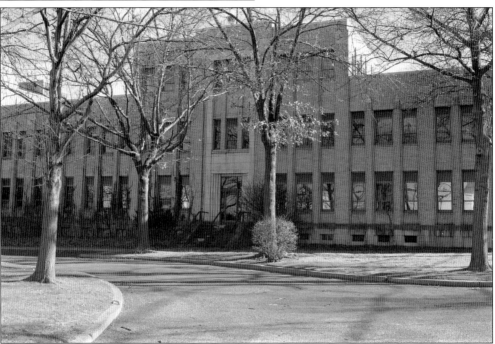

The stately Chevron Headquarters building on outer State Street remains well maintained externally but has been vacant for decades. As late as the 1960s, the building buzzed with hundreds of office workers and technical staff. Adjacent were the offices of the American Smelting and Refining Company.

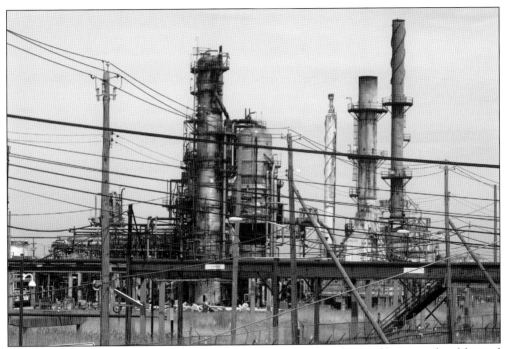

After 1983, the Chevron Oil Company stopped production of gasoline and heating oil and focused on large-scale asphalt production. The dense population in the area made this a profitable business, and the Chevron Asphalt Plant remains as the surviving part of the old refinery. The plant had previously been the Barber Asphalt Plant when it was owned by California Oil.

The impressive and picturesque Maurer railroad station was built by a Maurer company in 1894 to serve a thriving industrial community. Located on the northbound track of the Central Railroad, the brick building included a post office that became part of the Perth Amboy postal system. A freight station was added in 1911 on the southbound track. The station name was changed to Barber in 1938. (PAFPL.)

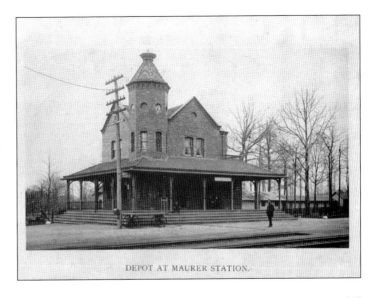

DEPOT AT MAURER STATION.

The iconic Perth Amboy "Hole in the Wall" on Maurer Road remains today, although Maurer Road is now closed to the public and serves only as an access road for Buckeye Oil. This one-lane underpass allowed Maurer Road to bisect the Chevron refinery, serve as the only connection between State Street and Amboy Avenue north of Hall Avenue, and challenge inexperienced drivers. The Chevron Asphalt Plant looms in the background.

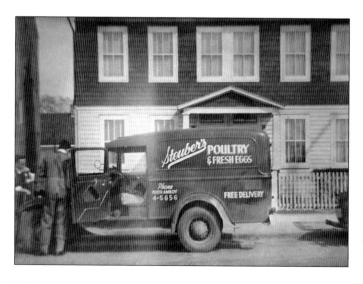

A neighborhood landmark on Amboy Avenue, between Ashley and Thomas Streets, Steuber's Poultry Market was a family business for more than 60 years. In this 1940s photograph are founder Charles Steuber and his son/co-owner Charles Steuber Jr., with their truck parked in front of the home and business. Third-generation owner Jeff Steuber sold the business in 2011. (Courtesy of the Steuber family.)

Francis Street Park is the only recreation facility in the Budapest neighborhood. In the mid-1950s, it was equipped with the city's "standard" swing sets: large "adult" swings, child swings, and the unique "horse" swings. Today, the upgraded park features a new basketball court, swings, slides, and a table and bench area. The dirt field is now grass, and a new water fountain has been added. (PAFPL.)

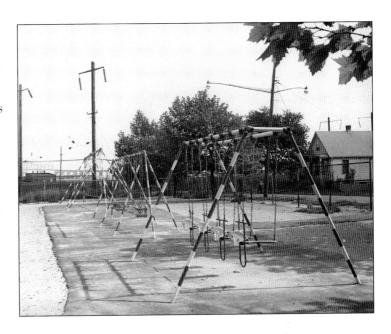

In the 1950s, children of all ages enjoyed playing in the Budapest neighborhood's Francis Street Park and on the tracks of the Pennsylvania Railroad, which formed the eastern boundary of the park. The Chevron "Cat Cracker" and the tall "Twin Stacks" are visible here. Chevron Oil structures and operations were part of everyday life for residents of the Budapest neighborhood. (PAFPL.)

The Pennsylvania Railroad "Duck Under" tunnel was a shortcut from the Budapest neighborhood to outer State Street and Rudyk Park. Tunnel users included factory workers, shoppers, and riders of the Public Service Bus No. 62 on State Street. The tunnel enjoyed a frightening reputation; with limited visibility around the curving track, many people were surprised to meet an unannounced train coming the other way.

Believe It or Not! Ripley-about AMERICA!

INTERBORO TRUCKING COMPANY, Inc.

PERTH AMBOY
255 SPRUCE ST.
P. A. 4-0126—4-0127

NEW YORK
38 PEARL ST.
BOwling Green 9-6163-6164

"A Load on Our Truck Is a Load off Your Mind"

The Interboro Trucking Company, located on Summit Avenue, was typical of the small businesses that existed between homes in the Northern neighborhood. It was across the street from the Ace Sign Shop, which remains in operation today. Many small businesses dotted the Northern neighborhood, from machine shops to farm stands. The large Daval handbag factory, on Amboy Avenue, was across from Steuber's Poultry Market and Hari's Auto Body Shop.

Imposing No. 9 School has never looked better. The school has been converted into condominiums; the Lawrence Street playgrounds are now grass; and the large "boys' playground" is now a parking lot. The former boys' entrance on the school's east side faced Spruce Street, where fifth-grade school patrols watched and maintained order.

As shown in this 1950s photograph, the front entrance to No. 9 School on Lawrence Street was the site of the school's annual Flag Day concerts, at which time it was customary for students to play their tonettes. These plastic wind instruments were a standard part of the musical education of elementary school students throughout the city.

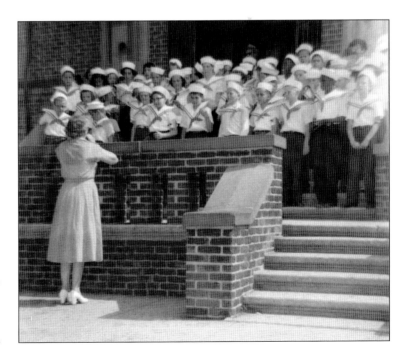

In this 1950s image, a May crowning can be seen at Our Lady of Fatima Church, which was located on Lawrence Street near Amboy Avenue. The church opened in the 1950s to serve the Portuguese-speaking and Spanish-speaking populations of the Northern neighborhood. A corner of No. 9 School can be seen in the back of this photograph.

The stone wall of the main entrance to Albert G. Waters Stadium, on Francis Street, was an impressive addition to the project that created the stadium. When the wall was determined to be dangerously deteriorated, it was scheduled to be demolished and replaced. However, local historians and concerned citizens stopped the initiative, and the wall is now scheduled to be fully restored to its original condition.

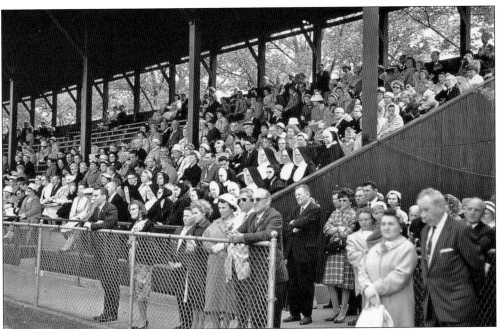

The home team's side of Waters Stadium was truly a grandstand, with tiered seating and a full roof. Under the grandstand were locker rooms, restrooms, a snack bar concession, and a storage area for maintenance equipment. The upper level of seating also contained a press-box area for journalists. As shown in this 1962 photograph, the stadium was also used by church and scout groups for viewing special events.

Pictured in 1962, a Catholic organization is using Waters Stadium for the organization's May Crowning of the Virgin Mary. Participants can be seen representing the rosary on the same Waters Stadium field that was used for Perth Amboy High School's outdoor athletic events. Behind the visitors' bleachers in the distant background, the California Oil Cat Cracker and the twin smokestacks can be seen.

Track meets at Waters Stadium were popular events for spectators, since the raised and covered home side grandstand allowed for unobstructed viewing of most events. Sprints were held in front of the grandstand seats, where the finish line was located for longer races. The track encircled the football field, and coaches and players lined the inside of the track to cheer on participants. (IR.)

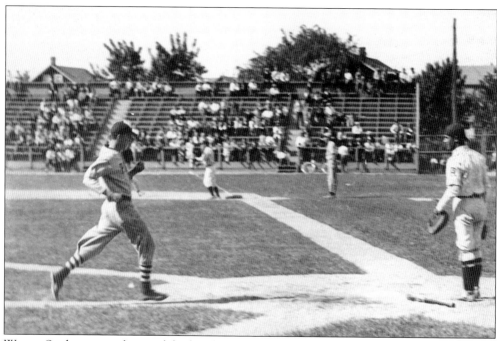

Waters Stadium was also used for baseball games, and its unique configuration provided a "homefield advantage" to Perth Amboy teams. The short right-field wall had a low chain-link fence, and fans seated there were only a few feet from the players. The dirt baseball infield, seen in this photograph, remained during football season and presented a muddy challenge to runners and kickers. (IR.)

The sprawling "new" Perth Amboy High School, on Eagle Avenue, runs from Francis Street and Waters Stadium all the way to the Pennsylvania Railroad tracks. Built in 1971 as a "state of the art" school, the rapid growth of the city's population has caused the school to be almost 50 percent over capacity. A replacement high school is now under construction on Convery Boulevard, at the site of Delaney Homes.

Occupying some of the highest ground in Perth Amboy, Alpine Cemetery on Amboy Avenue dates back to the Civil War. The elevation gives visitors panoramic views of the neighborhood and the city, including Waters Stadium, St. Mary's Cemetery, and the Outerbridge Crossing. Between the centuries-old monuments and looking toward Amboy Avenue, both Shull School and St. John's Lutheran Church can be seen in the background.

The Perth Amboy Firemen's monument is on the Alpine Cemetery hillside overlooking Amboy Avenue. The monument is dedicated to all of the Perth Amboy firemen who have been lost in service. The fireman is aligned with the entrance and the main road into St. Mary's Cemetery and the center of the Waters Stadium football field.

This dedication of the World War I doughboy statue on November 11, 1930, was a tribute to World War I deceased. Designed by E.M. Viquesney, the statue was cast in bronze from the original. The monument was originally located between Pfeiffer Boulevard and Waltrous Avenue and was moved in the 1970s to Arnesen Square at New Brunswick Avenue and Madison Avenue. (PAFPL.)

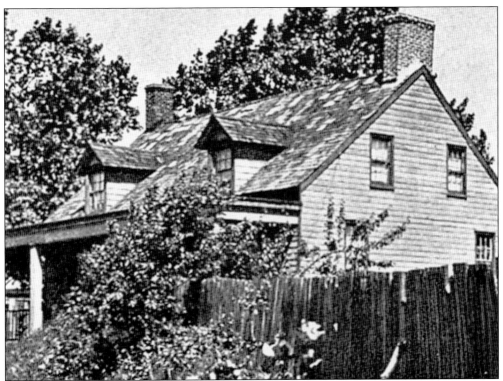

In the early 20th century, the northwestern section of Perth Amboy remained rural and predominantly farmland, except for the Valentine Brothers' clay pits, just north of Waltrous Lane (predecessor to Pfeiffer Boulevard). While many individuals owned large plots of land in this area, one of the largest plots was owned by the Maurer family, whose land extended far eastward. The Cook Farm House seen in this image is located at the intersection of Waltrous Lane and Raritan Avenue on this 1912 map. The rural character soon vanished when the Witco Chemical plant was built near the large California Oil storage tanks. The Delaney and Dunlap Homes were constructed to provide affordable housing for veterans, and the entire area is now mostly residential, except for businesses on Convery Boulevard and Pfeiffer Boulevard and cemeteries on Florida Grove Road. (MEP.)

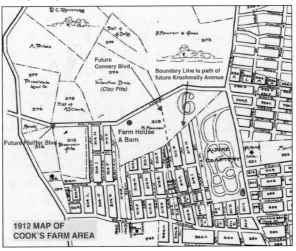

In 1894, Congregation Beth Mordecai purchased this land on Florida Grove Road for its cemetery. The first burial, in 1894, was Max ("Mordecai," in Hebrew) Wolff, in whose memory the synagogue was named and this cemetery was dedicated in 1896. Many of the synagogue's founders and early leaders and community leaders are buried at this cemetery.

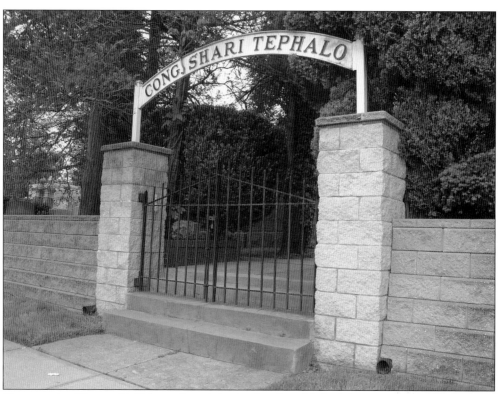

Congregation Shaarey Tefiloh purchased this land and established this cemetery at the corner of Florida Grove Road and Bingle Street in 1917. The synagogue's founders and early leaders were buried here, and so was Cantor Hirsch L. Chazin, who served as cantor for more than 55 years. The adjacent cemetery on Bingle Street was added in 1954 when the United Hebrew Association of Perth Amboy transferred ownership to the synagogue.

INDEX

ABOUT PROPRIETARY HOUSE

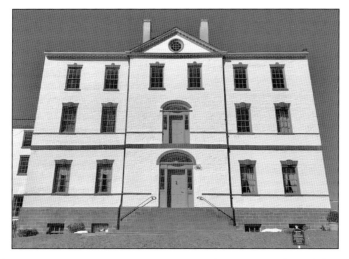

A priceless link to our nation's past, Proprietary House has witnessed much history in the more than 250 years the building has survived.

Built in 1762–1764 by the East Jersey Proprietors, Proprietary House in Perth Amboy is the only official royal governor's mansion still standing in the 13 original British colonies. New Jersey's last royal governor, William Franklin, and his wife moved into Proprietary House in 1774. The following year, the governor's famous father, Ben Franklin, visited Proprietary House and tried in vain to convince his son to embrace the cause of American independence. But the governor remained loyal to Britain and King George III. The Continental Congress considered William Franklin to be a traitor and ordered his arrest. On June 19, 1776, when Governor Franklin—the last of the colonial royal governors attempting to cling to power—was taken into custody by Patriot forces, Britain's rule over its 13 American colonies in effect came to an end at Proprietary House. Led away to trial and prison, Franklin never returned to his Perth Amboy mansion.

Damaged by fire in the mid-1780s, the building was purchased and restored by John Rattoone during the 1790s. Rattoone, secretly a courier for Benedict Arnold during the Revolution, lived in the mansion until 1808, when it was sold to a New York developer who enlarged the building and transformed it into an elegant resort hotel with the name Brighton House. During the 19th century, the former royal governor's mansion functioned not only as an upscale hotel, but also as the home of one of America's wealthiest men. In 1883, the mansion became a home for retired ministers and took on the name Westminster. During the early 20th century, the building continued to be known as the Westminster and again operated as a hotel. By the mid-1900s, the Westminster functioned as an apartment/boarding house that served many recent immigrants.

Proprietary House Association is a 501(c)(3) tax-exempt organization dedicated to the preservation and restoration of Proprietary House as a historical museum, landmark, and repository. Ongoing restoration of Proprietary House and operation of its museum are enabled by countless volunteer hours and the financial support of history-loving donors.

If you cherish our history and wish to help preserve Perth Amboy's historic treasure, please contact:

Proprietary House Association
149 Kearny Avenue, Perth Amboy, New Jersey, 08861
Phone: (732) 826-5527
Email: info@theproprietaryhouse.org
Website: www.theproprietaryhouse.org
Follow on Facebook: Proprietary House Museum

Discover Thousands of Local History Books Featuring Millions of Vintage Images

Arcadia Publishing, the leading local history publisher in the United States, is committed to making history accessible and meaningful through publishing books that celebrate and preserve the heritage of America's people and places.

Find more books like this at
www.arcadiapublishing.com

Search for your hometown history, your old stomping grounds, and even your favorite sports team.